botanical
illustration

the first ten lessons

botanical
illustration

the first ten lessons

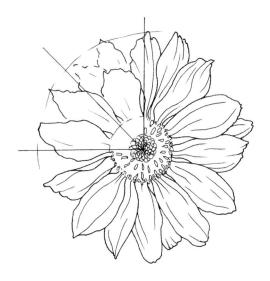

Valerie C. Price

BLOOMSBURY
LONDON · NEW DELHI · NEW YORK · SYDNEY

For my mother and my daughter,
from whom I learn.

First published in Great Britain 2012
Bloomsbury Publishing Plc
50 Bedford Square
London WC1B 3DP

www.bloomsbury.com

ISBN: 978-1-4081-5203-4

A CIP catalogue record for this book is available from the
British Library

Commissioning editor: Susan James
Project manager: Agnes Upshall
Copy editor: Jane Anson
Cover design: Sutchinda Thompson
Page design: Susan McIntyre

Typeset in 9.5 on 15pt FS Me

This book is produced using paper that is made from
wood grown in managed, sustainable forests. It is
natural, renewable and recyclable. The logging and
manufacturing processes conform to the environmental
regulations of the country of origin.

Printed and bound in China.

Contents

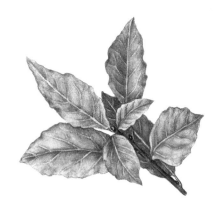

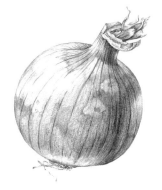

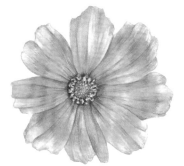

Introduction

The history of botanical illustration is a long and venerable one, and has been dealt with thoroughly many times before. Suffice to say, that in learning the art of botanical illustration, you will be joining the ranks of those who have saved lives and species, illuminated dull texts, and given pleasure to millions, since printing developed sufficiently to merit the time and effort required to produce an image of sufficient detail and clarity to make identification of plants possible.

Historically, botanical illustration has been the domain of men such as Ehert, Redoute and Hooker, with the occasional addition of women such as Marianne North, and flights of fancy by Edwardian ladies and their diaries. Today, exhibitions of botanical work are often the inspiration that prompts beginners to reach for pencils and watercolours to try to emulate the work they admire.

Botanical illustration appeals on many different levels and students begin learning the skills needed for a variety of reasons. Some love plants and flowers, wishing to record their favourites from their garden or greenhouse; others find the appeal of detail and the technical aspect of plant form and structure irresistible; while some want to experiment with pens, pencils and watercolour, stretching their skills and learning new techniques.

I became a freelance botanical illustrator after gaining a degree in scientific illustration, but looking back through my school work, flowers featured in my art portfolio even then, so perhaps I had no choice in the matter. While at college, I spent some time working in the Herbarium at Kew Gardens, illustrating many different plants, especially orchids. Later, I went on to create a number of illustrations for the *Kew Magazine* (*Curtis's Botanical Magazine*) in both pen and ink, and watercolour. Working under the critical eye of a botanist at Kew certainly keeps you on your toes in terms of detail and accuracy. The Royal Horticultural Society, Collins, Quarto, Dorling Kindersley and many other publishers of books about plants, gardening and cookery commissioned my work. I have also taken part in various exhibitions,

including the Orangery at Kew, the Society of Botanical Illustrators in Westminster, and the Hunt Institute for Botanical Art, at Carnegie Mellon University.

While still being available for freelance work, I am now teaching at several venues in Oxfordshire. I have developed a course of ten two-hour lessons which covers basic techniques and gradually builds skill levels, giving a thorough grounding in observational drawing and recording detail of line, form, structure and colour. You may find that looking at plants this way opens your eyes to a new way of seeing the world around you, so that colours can become brighter, patterns more identifiable, and the shape and form of familiar natural objects move into sharper focus. This book is a written form of those lessons aimed at the beginner, as well as a guide and reminder to more proficient students, and for anyone who cannot look at a flower without wondering 'how?', why?', 'where?'. This will not be a wordy tome, discussing the merits of one artist or technique over another, or filled with illustrations by other people, but simply a straightforward account of how I achieve a finished piece of work, and how you can do the same. I will include step-by-step illustrations to help you, along with advice on materials and colours that will hopefully guide you on your way to becoming an accomplished botanical illustrator.

These ten lessons are designed to give you the skills you will need. They will build on your expertise, enable you to use new techniques, and improve your confidence, encouraging you to tackle more complex subjects. As you work through the book, your observational skills will improve, allowing you to record the habit, form and structure of plants, to identify pattern and shape, and to mix and apply watercolour in delicate glazes. By referring back to earlier lessons, the book will help you to consolidate your learning, ensuring that you can continue to apply these newly acquired skills. The book is not to be copied from: you will not learn that way.

Instead, it is intended that you read it first, place it alongside your own work, and refer to it as you illustrate your own subject. Imagine me looking over your shoulder, checking the accuracy of your work and asking questions.

Observation is the key. Only by having a plant in front of you that you can observe, question, and measure, will it be possible to produce an accurate botanical illustration. These lessons are designed to be at least two hours long. Spend at least that amount of time working on each illustration. The final lesson would take at least twenty hours to complete.

Equipment

As a great believer in blame, I am convinced that the first thing to look at if things go wrong, is your equipment. I also believe in confidence, so the last thing to blame is your own ability.

Buy the best equipment you can afford, but not so expensive that you are too scared to use it, or feel under too much pressure if you're not having fun.

Watercolours

You may already own a set of paints, so start with them. Really cheap and nasty paints will do nothing for you, and children's sets will not behave well, being grainy and less colourfast. A set of student's watercolours may be fine to start you off, or a set of sketcher's paints that has a limited number of colours. Paints aimed at landscape artists may have a different, more earthy, range of colours. Winsor and Newton produce excellent watercolours at a range of prices, artists' quality being the best and most expensive. One individual colour from this range can cost as much as a whole set of sketcher's paints, but there are some bargains to be had, and shopping online can sometimes be cheaper. Watercolours are available in tubes, pans (little cakes of colour) or half-pans (smaller cakes of colour). Tubes can be wasteful, as you may find yourself washing away unused paint in order to keep your palette clean. As very little paint is needed, half-pans are usually big enough. I prefer to use half-pans of artists' quality watercolour.

Rather than buying a huge range, start with about twelve basic colours, and add to them as you need to:

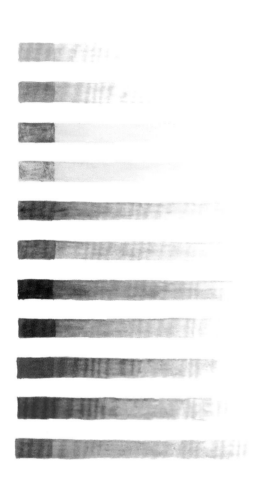

- Lemon Yellow

- Cadmium Yellow

- Yellow Ochre

- Sap Green

- Viridian

- Ultramarine

- Cobalt Blue

- Payne's Grey

- Burnt Umber

- Alizarin Crimson

- Cadmium Red

- Burnt Sienna

Figure 1. Colour chart.

You will not need black: there is no black in nature, only deep, dark colours. And you will not need white, as your paper will provide that. Mixing white into your paint will make it cloudy and opaque and ruin the effect of light, and the luminosity that you are trying to create. Having said that, white gouache can be used at the end of your work, if you need to pick out tiny white hairs or thorns.

Botanical illustration

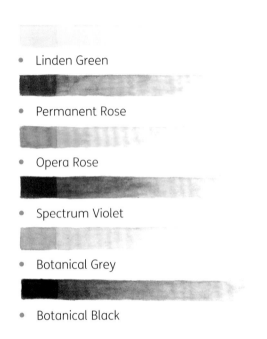

- Linden Green

- Permanent Rose

- Opera Rose

- Spectrum Violet

- Botanical Grey

- Botanical Black

Figure 2. Extra colours.

A word on gouache: this is an opaque watercolour, while watercolour is translucent. Gouache can be applied in a dilute wash, and indeed, can add valuable colours to your palette. Linden Green is a very bright intense yellow/green, which can be mixed with Cobalt Blue to give a lovely fresh green that is an ideal starting point for foliage. Spectrum Violet is a deep, strong purple that can be used as a dilute wash for many flowers such as irises and bluebells.

You may need to buy other watercolours as you work on different subjects. If you use a colour straight from the pan, it will be strong and vibrant, but not necessarily correct; if you mix two colours you will achieve more subtlety, and if you mix more than three colours together you may get mud. So take care: rather than mixing too many colours together it is often better to lay separate glazes of colour, which will give you a more subtle and delicate result. It is impossible to mix a very bright colour, so to achieve a very bright pink you will need Opera Rose or Permanent Rose. It is better to mix the greens you will use, as the ready-made greens are often too synthetic looking, or too olive, so buy more blues and yellows instead.

For my colour chart, I have mixed 'Botanical Grey' (a mixture of Cobalt Blue, Burnt Umber and Payne's Grey) for painting white flowers, and 'Botanical Black' (a mixture of Alizarin Crimson, Ultramarine and Viridian) for deep, velvety dark colours like sloes or blackberries.

The rules are that if you use a colour straight from the pan it will be bright, and may be too bright. If you mix two colours together, you get a more subtle colour. If you mix more than three colours together, you may get mud. However, sometimes mud can be a good thing.

If your paints are new to you, play with them, practising graduated washes, as I have done here, or make colour charts that overlay each other, so that you can see what Lemon Yellow and Cobalt Blue are like together.

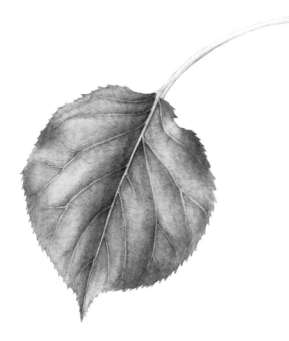

you need them again. For the time being, an A4 pad is big enough, though as you continue, you may need to buy an A3 pad, for larger compositions. Anything smaller than A4 will be uncomfortable for your hand to work on.

Watercolour paper

Paper for watercolour is sold by size (available as sheets or pads), weight (now in grams) and texture. Traditionally, watercolour paper, especially for landscapes, is rough in texture (called 'not-' or 'cold-pressed'). This surface allows an uneven layer of paint to be applied, creating light within the texture. Some students like to use this type of paper, but I prefer a smooth 'hot-pressed' paper, which can take repeated washes but is smooth enough to pick up line and detail without the surface of the paper interfering. There are many different papers on the market, and it is worth experimenting with different surfaces till you find one that suits you, not forgetting to blame the wrong paper for bad results.

The ultimate surface for botanical illustration is vellum (prepared calfskin). It has an off-white colour which may be slightly irregular, and is very smooth to paint on, lifting off a little too easily to be comfortable with large washes. However, it loves dry brushwork, and nothing can match it for luminosity, making the colours

Treat your paints with respect. Allow them to dry after use, then close the lid or cover over with a piece of clean paper to keep them dust free; ditto your palette, so that you have one less thing to blame.

Paper

You will need an A4 sketchbook of good-quality cartridge paper. You may like to treat yourself to a spiral-bound hardback pad, in which you can do all your preparatory drawings. It will help you to feel organised, and you can take pride in it, and know that your drawings are safe and secure, and easy to locate should

Botanical illustration

of your finished work glow with light. It is not suitable for beginners, being temperamental and unforgiving, but well worth playing on if you can get hold of some.

The paper I would recommend to a novice would be smooth, white, acid free and over 300 grams. Anything less than this will need to be stretched, though it is often a safe precaution to tape your paper firmly to a stable board, to prevent buckling. There are some lovely papers available in prepared pads, which have been glued all the way around to prevent warping. They are, however, quite expensive, and can be limiting as you only have access to one sheet at a time – a problem if you need to start a new illustration before you have finished the first. To remove a finished piece, slide a clean, blunt blade (a palette knife, or a butter knife) into the opening (often at the bottom or in one corner) and carefully move around the edges until detached. Papers to try under this heading would be:

- Fabriano Artistico HP, available as either Traditional or Extra White

- Arches Aquarelle HP

- Saunders Waterford HP.

An easier and cheaper option is to stretch your own paper; any paper will warp and buckle if subjected to sufficient water. If you need to stretch paper, make this your first job, allowing plenty of time for it to dry out. To stretch paper, take a board 3–4 cm bigger than your paper. Use exterior plywood, or something that can take repeated wettings, not fibreboard (MDF or chipboard), which might disintegrate. Use a flat, smooth (but not shiny) piece of board. Sand it if necessary, to make it smooth and remove splinters, and scrub it to remove any staining, then allow to dry. Remove a sheet of your paper, making a pencil mark in one corner so that you know which is the right side (paper has a wrong side, which you can blame if necessary, but you will not need to if you have marked the correct way up). If you are cutting smaller sheets from a larger piece of paper, mark these in the corners, too, as the wrong side of the paper will not be nice to work on. Watch out for watermarks that will identify the paper and show which is the correct side (you can read them when held up to the light), but do not look so nice if incorporated into your illustration. If all else fails, try looking through a magnifying glass: the back of the paper may appear to have a woven surface, with hollows, whereas the front should be smoother. Cut strips of gummed brown paper tape to go around the perimeter of your paper. Ensure everything is clean and free from grease. Hold your paper by opposite corners and run it under a gently flowing tap until you have wetted the whole surface, then turn to wet the back. Do not over-

wet the paper. Allow it to drain for a moment, and then offer it to your board, positioning it centrally. Reposition by the corners, diagonally, if needed. Speed is of the essence now, so that your paper is not damaged or allowed to warp. Now wet one strip of tape and squeeze out the excess water. Lay it along one side of the paper, half on the paper and half on the board. Flatten it with your fingers. Don't worry if the paper starts to buckle, but continue taping the paper down until the entire perimeter is secured. If the paper is very wet, tilt it a little to drain, to prevent watermarks, and then lay it flat to dry. Don't leave it in direct sunlight or heat. Drying may take 2–3 hours, preferably overnight, and any buckling should disappear, leaving you with a smooth, flat and stable surface on which to work. When applying washes, the paper may still buckle, but will lie flat again when dry. The paper is only 'stretched' while it is on the board, so do not remove it until your illustration is complete. Once dry, keep it clean with a covering of clean paper. If necessary, you can stretch another piece of paper on the back of your board, as long as you have protected the paper at the front. To remove the finished work, lay a metal ruler along the inside edge of the tape, and carefully cut along the perimeter of the paper side with a scalpel or craft knife. Lift off the paper and store the artwork carefully. Remove the old tape and scrub the board (unless there is a second illustration on the back) to remove any tape or gum. Then re-use

as needed. Papers to try that require stretching include:

- Goldline Artist's Pad 200 gm (pink cover)

- Loose sheets of paper such as Fabriano Classico

- Fabriano Artistico HP

- Arches Aquarelle HP

- Saunders Waterford HP.

Critical assessment

- If the paper is too wet, it may buckle and not lie flat when dry. Try wetting it less, or getting the wet paper onto the board faster. Over-wetted paper can also cause watermarks, shiny patches that can be seen from one angle.

- If the tape tears away, the paper may be stronger than board, so use a more substantial board. This can also cause the board to warp.

(continued overleaf)

Critical assessment

- Damage to the finished paper may be due to over-handling (paper is very fragile while wet), or grease marks picked up from the sink area, or hand cream (which is banned).

- If the paper is hard to remove from the board, the gum strip may have been too wet, causing glue to seep out. Next time, remove more water from the tape.

- Stretching any paper will open up the surface a little, but if you are painting a large area, or using dark colours that will require repeated washes, it is a comforting safety net.

- Papers that are ready to use, with the above proviso, include Fabriano Classico 5 HP 50% cotton (one of my favourites), Langton HP and anything above 300 gm (140 lb).

Pencils

A selection of pencils is essential. I like to use a mechanical pencil (technical drawing pencil) with a 0.5 lead, which gives a firm, sharp line. I have two of these, one with an HB lead and one with a 2H lead, and I have been known to sharpen this. Pencils with thicker leads are available, as are thinner leads, but these break too easily. A 2H, an HB and a 2B pencil should be enough for most projects, but be warned: different brands behave slightly differently, with Derwent being 1–2 grades softer than average. Staedtler Mars tradition (red and black) are good to use. Never buy a cheap set of pencils; they will all be the same grade and no pleasure to use.

Sharpener

Use a good-quality sharpener or a craft knife to keep your pencil sharp. This is the only way to produce a clear, fine line. Alternatively, see above, and use a mechanical pencil.

Eraser

There are many different types of eraser available. My favourite is a Winsor and Newton Griffin eraser, which I slice bits off, to only rub out a tiny bit at a time. Avoid hard plastic erasers, which can damage your paper, or putty erasers, which can spread graphite. Battery-powered erasers are available, if you feel the need.

Tracing paper

This will be used to transfer your working drawing to your prepared watercolour paper.

Pens

A selection of pens will be useful. Fine fibre-tipped pens are available quite cheaply. We will be using them for pen and ink studies, but some people like to ink over parts of their working drawings to clarify the line. Black ink is best: a fine nib such as 0.1 mm and a thicker 0.5 mm will be sufficient.

Blotting paper

This is essential for unavoidable mistakes. Paper towels do not have the same lifting capability.

Magic sponge

This is a wonderful product. It is intended for removing stains such as marks on cups or vinyl floors, but if used carefully it can clean up the biggest mistakes in watercolour, and even create light and shine when you have neglected to do so. To use it, dampen a small piece with clean water and rub it gently over the mark you wish to remove, as you would with an eraser. Blot with blotting paper. Repeat if necessary, but take care not to damage the paper. Hopefully, any little white pieces that appear will only be the magic sponge, which disintegrates as it is used. Some papers, especially cold-pressed paper, do not like magic sponge, so try it on a scrap first.

Paper towel

This is useful for restricting water on your brush when painting.

Palette

Ideally, choose a palette with a series of wells and slopes. You should mix colours in the wells, and dilute them on the slopes. Ceramic is best, though plastic is lighter and cheaper. Always wash a new palette with warm soapy water before the first use, to reduce surface tension (the paint will pool), and keep your palette clean while in use by covering it with a piece of paper to keep dust off, so that you can continue using the colours you have mixed. Wash your palette before starting work on a new picture, to prevent contamination of colours.

Brushes

Use an old, blunt brush for mixing paint. I find a flat one useful, but stay away from one that is too stiff, as it may pick up more paint than you need. For painting, choose brushes that come to a fine point. When buying a brush, test the tip in water, the bristles should come together to form a fine tip, and not split. Buy the best you can afford: remember that painting should be a pleasure, and it won't be if you are struggling with a rogue brush. Synthetic brushes are cheaper than sable, and can behave very well. The best brushes are Winsor and Newton Series 7, which are made from Kolinsky sable, but there are cheaper alternatives which are not bad substitutes. Choose a couple of sizes: 0 and 6 are good starting points. It is better to buy two good brushes than a packet containing a range of sizes that you can manage without. When you are painting, select the right size brush for the area you are working on, in the same way that you would not use a huge brush for painting window frames, or a half-inch brush for painting a wall. Store them with the protective tubes on, as you cannot repair a bent brush head. As your collection grows, consider storing them in a brush tube or case. Never leave your brush in water, as it will become permanently bent. Brushes wear out, and lose their tips. Of all the things to blame, the biggest would be a worn-out old brush: you cannot paint fine lines and detail if you are using a blunt brush. When working at Kew, I would get through a brush a week, which equates to a brush per illustration. Don't throw these old brushes out, just downgrade them to first washes, keeping your newest and best brush for fine detail and definition. Make sure you work out a system to recognise their respective decrepitude.

Water pot

Not too big, but clean and stable. Some people like to use two pots, one for mixing and one for painting, or one for reds and one for greens. Keep your pot clean and change the water frequently.

Toothbrush pot

A plastic toothbrush pot, the sort with a removable lid, with four holes in it, can hold a wayward flower in place superbly. (Thank you, Anne.)

Flower tube

A small plastic tube with a perforated rubber lid (available from florists) is perfect for keeping a single flower alive. It should be able to slot into your toothbrush pot for extra stability.

Masking tape

Useful for many things, including taping down paper that you are unsure requires stretching.

Masking fluid

This is vital when recording some stamens and veins. An area covered by masking fluid will not accept paint, so can allow you to leave out very fine lines, which can be dealt with at a later stage. It is liquid latex, and can be applied with a dip pen, ruling pen, or plastic applicator. Don't be tempted to use a brush, it will become clogged up so that you can't create fine lines, and will ruin the brush. Some masking fluids come in an applicator bottle; I have yet to find these satisfactory.

Easel

A small table easel is a useful accessory.
Many different styles are available, some with
a small drawer underneath, or a carrying
handle, or an adjustable support to raise and
lower the paper. Consider where and how
you are going to use it, before spending a
lot of money. It is possible to get a perfectly
adequate easel at an affordable price. If
an easel is unavailable, rest your work at a
slope. This is important, so that you do not
have a distorted view of your painting, and
so that washes behave in a predictable way,
i.e. running downhill, and also for the well-
being of your back and neck. (Hopefully, you
will become engrossed in your labours; a stiff
neck or bad back will put you off spending the
requisite hours on your next illustration.)

Figure 3. The work area, ready for action.

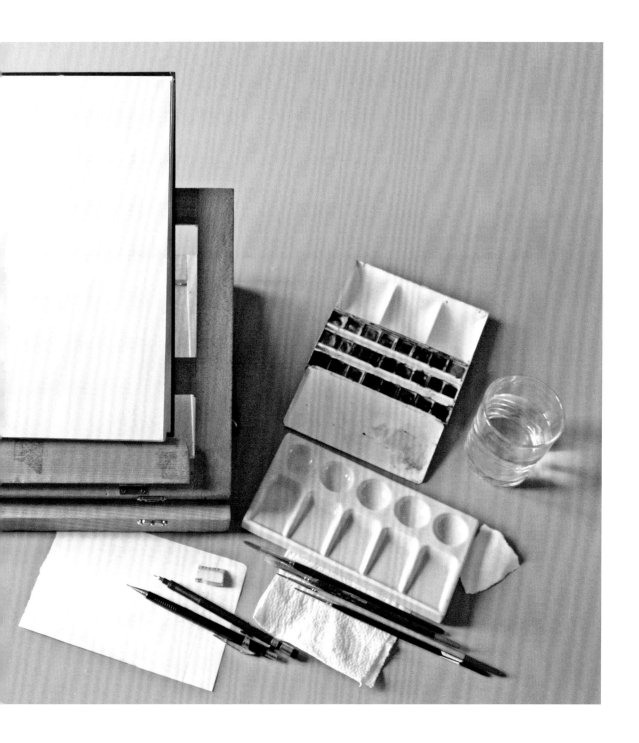

Preparation

Having amassed your equipment, consider where you are going to use it. Set aside an area that is clean and well lit. Natural light is always best, not only for your eyes, but also for identifying form and colour.

If you are right handed, position yourself with a window to your left; if left handed, the window should be to your right. You are aiming to have one source of light coming across your work, illuminating your subject (to create form) and your paper, without casting a shadow from your hand. Avoid facing your light source, as you will be unable to see form, because you will virtually be looking at a silhouette. Check that you can see the tip of your pencil clearly. Even then, unless you have access to a northern light, the light will change as the day progresses. If you need to work without natural light, try to get hold of a daylight bulb, which will give you better colour readings, and is kinder to your eyes. Position this light to your left if you are right handed, and to your right if you are left handed. Small adjustable halogen lamps are an acceptable substitute.

Sit comfortably; ensure that your chair is the correct height, and try to keep your back straight. A comfortable default position will make your observation of your subject easier, and will be much less stressful on your neck and back. Set your easel at a comfortable angle directly in front of you. If you do not have an easel, prop your work on books to achieve a comfortable slope. Right-handed illustrators should place their subject to their left, in maximum light. This leaves the right side of their easel free for equipment. Get into the habit of placing your pencils, paints, etc. in a particular place so that you can access them automatically. Not only is this ergonomic, it will also limit drips of paint across your work. (It's also useful in an emergency to know just where your blotting paper is.) For left-handed illustrators, the opposite will be best, i.e. subject

on your right and equipment on your left. Do take a break every so often, and roll your shoulders. Beware of becoming stiff if you become engrossed in your work. Do not put a cup of tea or coffee within reach of this task area, as it will only be a matter of time before you wash your paintbrush in it. And remember the ban on hand cream: watercolour will not lay on an oily surface. To this end, always protect your work with a scrap of clean paper under your hand. This will become your most vital tool. I use a piece of paper to measure my subject, check colour, and test the strength of paint before applying a wash, as well as protecting my work from smudges, smears, and sweat (we will be working quite hard).

The initial drawing will be in your sketchbook, to preserve your watercolour paper. Always spend some time considering your selected subject. Twist and turn it to get the best view, making it as typical of its kind as you can. Later, you can play games with your subject, recording unexpected angles, but for now,

make life easy for yourself. Show its best face; try to avoid foreshortening, and overlapping stems or leaves pointing at each other. The beauty of having a live subject in front of you is that you can look all around it, understanding its form, shape and structure. Consider the habit of your plant: how it grows, whether it climbs up or hangs down. Now keep it alive. If it is a flower, make sure it has water: it needs to last the duration of your illustration. Use your toothbrush pot or flower tube, or any water container (if necessary, tape your plant into position). For illustrations that will take longer, place your subject in an airtight box, with damp kitchen paper in the bottom, and store it in the fridge. Sometimes, 'Helping hands' (a weighted contraption with several arms and clips) can be useful to hold a piece of plant at the right angle and height. If your subject is a solid object, like an apple, place it on a piece of white paper. This will help with form and reflected light, and with colour, as you will be working on white paper, the same as your subject's background.

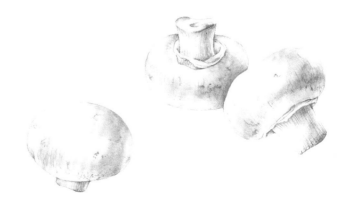

Composition

Try to think in odd numbers, as would a gardener or flower arranger, so that you illustrate, say, three or five objects.

Figure 4. A barcode arrangement can make a contemporary illustration, but take care with the spacing between the individual elements.

Figure 6. Consider the size, colour, and weight of the subjects, and experiment by moving them together and apart.

Figure 5. If you base your composition around a lopsided triangle, the illustration will have a relaxed and informal feel, and by grouping two items together, you can add weight and impact

Figure 7. These rules can apply to any area of colour, from apples to flowers.

Figure 8. Include the flower stems, linking and grounding the illustration, as well as describing the plant.

Figure 9. Keep the stems separate, so that the illustration is simple and elegant.

Space can be used to great effect, but too much unused paper can make an illustration look lost and empty. If you squeeze your illustration into a piece of paper that is too small, the composition will be cramped. In some cases, it may be desirable to crop your image, placing the bulb alongside the flowering stem, for instance – a long length of bare stem is not very attractive. Cropping an image can alter the focus, enhancing flowers by reducing the amount of foliage being depicted. It is a good idea to make two right-angled 'mounts' so that you can see what the finished appearance will be, as it is often hard to disregard the excess paper around your work. Make a series of quick sketches to try out different composition ideas. Setting your illustration off-centre works well, allowing you better use of the space you have. Plan out what elements or plants you will be drawing, so that you know how much space you will need. Avoid crossing stems: crossed lines become dynamic, creating a focal point you did not intend, and detracting from the attention the flowers deserve. Do not allow flowers or leaves to meet at points. It is better to move them apart, or allow them to overlap, than create a shape for themselves, as this can also make a distracting, dynamic shape. Place plants with care to avoid difficult foreshortening of leaves and flowers. By turning the subject just a little, you can make the whole image more attractive and informative.

Place your subject carefully to show it as much like itself as possible. A botanical illustration tells the story of the plant you are working on; it is your detailed and accurate representation of your subject. Position it to show its best and most descriptive features. Avoid 'lolly-popping' flowers (so that the stem is coming from the centre of the flower), as this will be less informative and can look like a child's drawing. Turning a flower slightly shows the junction of the stem and flower head, and will make it easier for you to demonstrate your skills. Adapt your composition to your subject matter, so that wild flowers are shown in a relaxed and informal way, while more structured plants such as lilies are given a more upright arrangement. Maintain the scale of your subject: a buttercup could look lost beside an open lily, a tall iris could overshadow a primrose. Show the natural habit of the plant or flower by thinking about how it grows, or where you found it: a climber can trail across the page, while a sunflower is recorded as upright. Use one side of the paper as a base, so that all stems originate from the same source, and consider how you will end the stems. Turn some of the flower heads in your composition, so that you give more information about their shape and structure, and add interest to your picture. Ideally, lead the eye around the page by positioning the blocks of colour (usually flowers), in a loose circle or a lopsided triangle.

Keep to a theme when selecting subject matter. Illustrate a plant to show the whole of its life cycle, with leaves, flowers and seeds. Draw wild flowers that are linked by habitat or season. Harmonise colours, and balance with foliage: green leaves offset perfectly the colours of the flowers they grow with, and enhance them beautifully. Toadstools can be shown growing amongst moss and grass. Hips, haws and berries make lovely seasonal subject matter. Herbs can be illustrated together, vegetables can be linked around a recipe, and fruit with a dissection makes an excellent study. Dried seed heads can be attractively arranged, and even bare stems, placed with care, can make a lovely subject. The simple things you find in hedgerows are often better subjects than the more exotic, sometimes too brightly coloured, hothouse plants.

Flower structure

A composite flower such as a daisy or sunflower (Figure 10a), is composed of many tiny flowers clustered together, and is basically a series of concentric circles, with petals radiating from the centre. Always ensure that the bases of the (ray) petals radiate from a central point. The centre of a daisy is made up of a spiral arrangement (the Fibonacci sequence) of disc florets, which also form

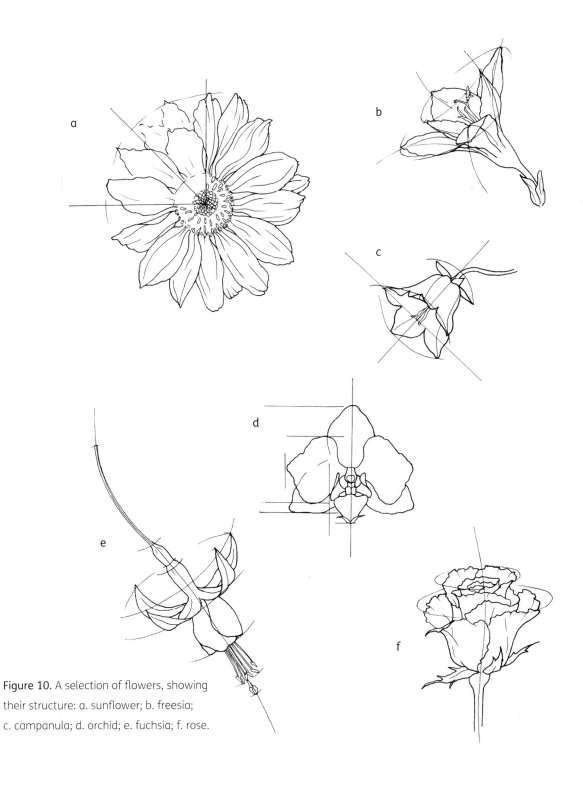

Figure 10. A selection of flowers, showing their structure: a. sunflower; b. freesia; c. campanula; d. orchid; e. fuchsia; f. rose.

Botanical illustration

circles that change as the flower ages. Begin by drawing the outer circle, measure the petals and the central disc (the total should add up to equal the outer measurement). These measurements should be the same all the way round. Mark in the four quarters like the numbers on a clock face: these will find the centre from which all else will follow. Draw a central line for each petal, making sure you keep to the correct direction. Measure the width of the petals and draw the edges tapering, then draw the detail of the tips.

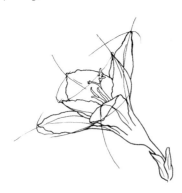

A flower with a funnel or trumpet shape, such as a freesia, is produced from arrangements of three petals (Figure 10b). Each of the two sections forms a triangle, but it is easier to visualise the petals forming circles, which will probably appear as ellipses. Always take your line up and out from the base of the flower, curving to show the movement and form of each petal, and then add the edge of the petal around that line. The stamens and stigma must also fit into the funnel.

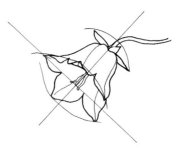

For a flower with a bell shape, such as a campanula (Figure 10c), begin your drawing by identifying the angle at which the flower hangs: an imaginary line through the centre. The fused base of the petals will form an ellipse at right angles to this, and the tips of the petals will form another ellipse. Draw the centre of each petal as it curves to form the bell and ends on the second ellipse. Cross-reference the measurements and spaces between each petal, then draw the outer edges. The stamens will attach to the stem within the bell, and must be shown to travel in that direction.

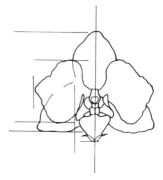

Orchids such as the *Phalaenopsis* in Figure 10d are symmetrical through their vertical axis (bilaterally symmetrical). If you are drawing the flower straight on, as I have, begin by drawing a vertical line through the centre. The column

(the fused reproductive organ) is joined to the stem, and the petals are attached around this. Measure each petal (they are actually sepals) radiating from this point. When you are satisfied with one side, trace this half of the drawing along the vertical line, and reverse it over to the other side. Make the necessary corrections to make the two sides identical.

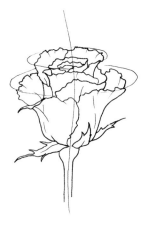

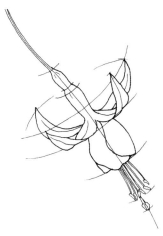

To draw a fuchsia (Figure 10e), draw a line that records the gently curving movement through the stalk and allow it to follow through and become the stigma. All the petals flow from this line. Draw a central line down through the tube at the top of the flower for each of the petals, (the tips will describe an ellipse), and then draw the outer edges. The lower ring of petals must also fit into this tube at the top, and repeat the ellipse of the outer petals. The stamens will travel out from the tube and hang around the stigma.

A complex flower like a rose (Figure 10f) is formed from many layers of petals, and can offer the biggest challenge. Measure the outer limits of the flower, and stay within these measurements. Draw in the central line, and look for rings formed by the petals. Add curving lines in the centre of each petal that describe a bowl shape. Think of the bud shape hidden within the petals, and make sure that the petals want to come out from the stem. This can often be discreetly enhanced by the delicate veining and feathered edges of the petals.

Observation is the key to accurate botanical illustration, so look, and then look again: understand the form and structure of your plant. Ask yourself questions: How is that leaf attached? Where does that stem come from? What happens to that petal? By understanding your plant you will be better able to illustrate it, describing, in paint, the plant you have in front of you.

Botanical illustration

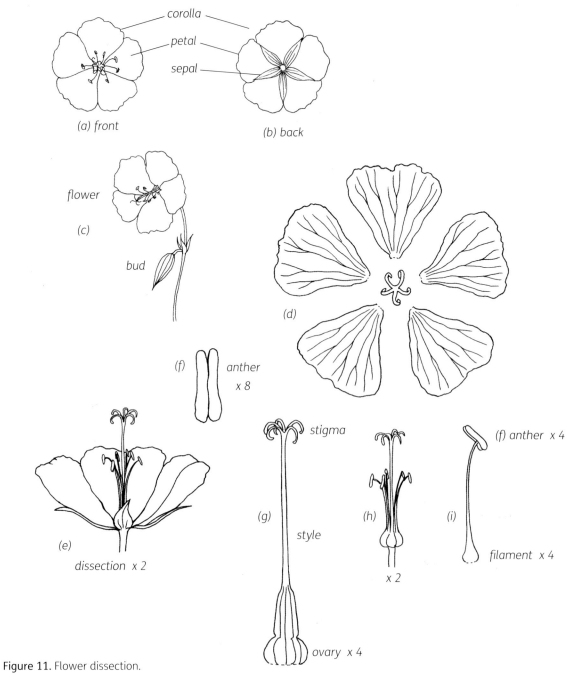

Figure 11. Flower dissection.

Dissection

It may help you to understand the shape and
structure of a flower, if you take one apart.
Use a magnifying glass to look carefully at its
component parts: an understanding of how it all
fits together will improve your ability to record
accurately. Obviously, only dissect a different
flower from the one you wish to draw whole.

Figure 11 shows a geranium flower, front (a)
and back (b), and a flower with a bud (c). The
exploded flower (d) is x2 (I simply pulled the
petals off) with a bird's-eye view of the stigma
in the middle. The drawing at lower left (e) is
x2, and I have dissected through the centre of
the flower. The anther (f) is enlarged to x8. I've
drawn the carpel (the stigma, style and ovary)
(g) to x4, the stigma and stamen (h) x2, and
the stamen, anther and filament (i) x4. To do
enlargements, use a scrap of paper or dividers,
and multiply measurements as required.

Perspective

A circular flower will only appear round when
viewed from directly head on (Figure 12). Seen
from above, it will be a series of concentric
circles. As you turn the flower away, the shape
will change into an ellipse, with a smaller
ellipse within it, centred on a point leading from

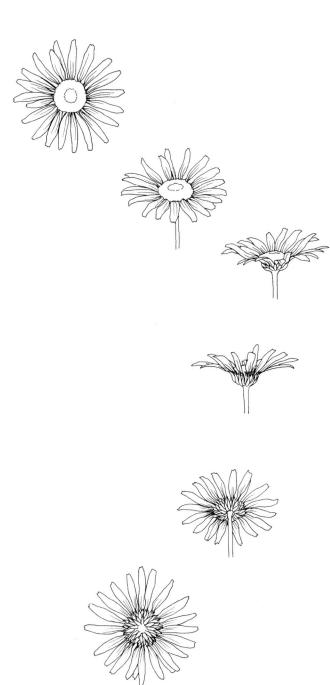

Figure 12. Flower perspective.

Botanical illustration

the stem. These ellipses will always match each other. If they don't, the drawing will not work – an outer ellipse cannot house an inner circle. As the ellipse becomes more extreme, so the petal shape will change, becoming foreshortened at the front and back, while the petals at the sides will appear thinner. In profile, the base of the flower (the sepals which form the calyx) will be apparent, as will the stem.

Always begin drawing a leaf by measuring along the central vein (midrib), then measure the width. It may help to draw the minor veins almost before putting in the outline, as they describe the shape. As the leaf rotates (Figure 13), the length will remain the same, but the width will alter, and the midrib will not be strictly in the centre. The minor veins will appear more acute and curving. Turn the leaf towards you, and it will appear to be foreshortened, so that the length is reduced, and the width remains the same. By drawing the curvature of the midrib, you will be able to accurately show the shape, perspective and direction.

Botanical terms to describe leaves are many and complex. You will not need to know these, but you will need to know the leaf that you are about to illustrate. Consider the shape, outline, stalk and venation before you even think about colour. Some leaves are compound (made up of more than one

Figure 13. Leaf perspective.

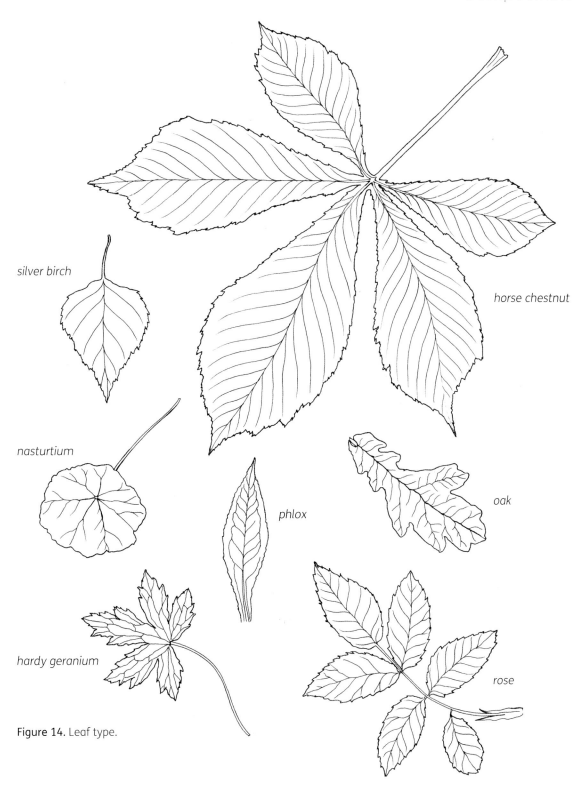

silver birch

horse chestnut

nasturtium

phlox

oak

hardy geranium

rose

Figure 14. Leaf type.

leaf), such as the horse chestnut or rose, others are palmate (deeply cut), such as the hardy geranium, or lobed like the oak. The shape of the leaf will vary, and the edge or margin may be smooth, serrated, or spiny. The veins are there to supply the leaf with water and minerals, and to return sugars to the plant, so their purpose is to cover as much of the leaf surface as possible. Some veins run parallel, as in lilies and grasses; others form a branching network. Look closely at the leaf you are working on. Hold it up to the light, or turn it over to examine it in detail. Always make the veins flow from the midrib to the minor veins, so that a consistent line is formed, without harsh angles. Leaves with serrated edges should be drawn as smooth initially, to ensure the correct shape, but you should always define the margins in detail, as they are such an important part of the plant's characteristics.

Leaves are arranged on the plant to maximise their access to light. Most commonly, leaves grow alternately or in pairs. Plants such as ivy have leaves that grow alternately and cause a distinct movement in the stem at each junction (node). This can often be seen more easily from one side, so check that you have observed the whole plant before beginning. The stem will thicken at each junction, and there may be a bud at this point. Again, ensure that your line flows freely up from the main stem. Leaves that twist and turn are shown by drawing in the midrib first, and then the outer edges. It is helpful to draw in all the lines, even the ones that won't be seen, and then rub out the parts that are hidden. The edges should not cross, or come to an extreme point, or be thicker than the rest of the leaf at any point. Think of the midrib as a framework or hanger for the rest of the leaf. The leaves at the base of the plant may be arranged in a whorl or rosette, so unless you are illustrating the whole plant, do not stop at a leaf junction, but draw in a little bit of the stem below, so that your drawing does not appear to be saying that this is the whole plant.

Make a detailed drawing of a plant in your sketchbook, then turn your drawing upside down, or look at it in a small mirror, and you will see if it is balanced. This gives you a different perspective on your work, which you will have been looking at very closely. Make any changes now, before preparing to paint. As this preparatory drawing is done in your sketchbook, there are now opportunities to play with your composition, moving elements around until you are satisfied with the result.

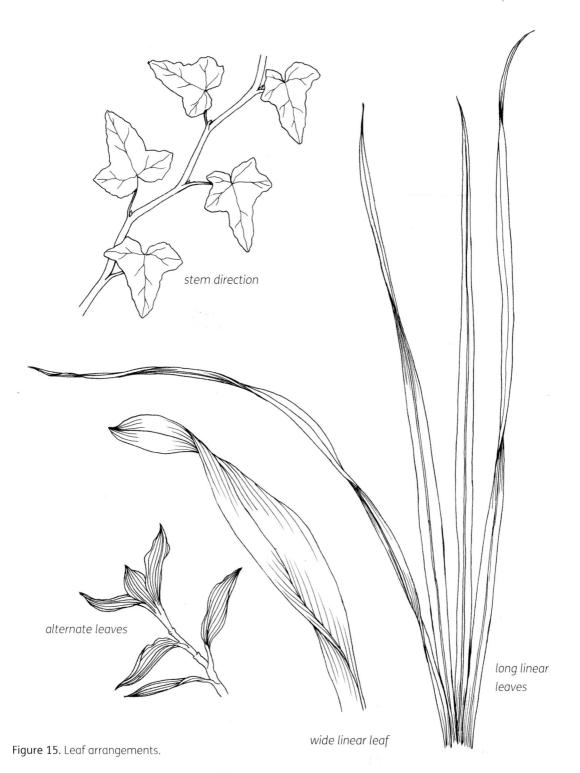

stem direction

alternate leaves

wide linear leaf

*long linear
leaves*

Figure 15. Leaf arrangements.

Botanical illustration

Tracing

Figure 16. The completed drawing in the sketchbook.

Figure 17.

When you are happy with your drawing and composition, you will need to transfer it to your prepared watercolour paper. By making a working drawing in your sketchbook, you have been able to revisit your drawing several times, improving and refining it. You can use this drawing to make colour and shading notes, but more importantly, you will have preserved the surface of your watercolour paper. Some papers are very temperamental, and can easily be damaged by repeated rubbing out. Damaged paper is difficult to paint on, and will certainly give you something to blame.

If you have a light box, you can trace directly on to your paper (though not if it is stretched on a board, or in a glued pad). Place your drawing as a single sheet of paper on the light box, lightly tape the watercolour paper to it, repositioning it as necessary, and lightly trace your image using a 2H pencil. Take care not to press too hard. When finished, gently rub out any lines that have come out too hard.

To transfer with tracing paper, cut a piece of tracing paper to size, take small pieces of masking tape and remove some of the tacky, and position the tracing paper over

Figure 18.

Figure 19.

your drawing, taping it into place (Figure 17). Use a 2H pencil to draw over the lines of your drawing, including details such as veins.

Lift off the tracing and turn it over onto a scrap of paper (Figure 18). Scribble over the reversed image with a 2B pencil. Do not press too hard, and to avoid obscuring your image, slant the pencil at a slightly different angle to most of your drawing lines.

Now place this the right way up on your watercolour paper, positioning with care (Figure 19). The masking tape will now be sticky side down, so reattach it, and use the 2H pencil to go over your drawing onto the watercolour

paper. Lift a corner to check that you are pressing hard enough, but don't press too hard or you will engrave into the paper.

Now remove the tracing paper: you should have a soft graphite representation of your original image. Using the 2H pencil, redraw the image again, using the original drawing as a reference, and rechecking details from your subject if you need to. Then carefully rub out the excess graphite from the 2B pencil, leaving a perfect reproduction in fine line that you can only just see, so that when you start to paint, the pencil line will disappear. Figure 21 shows the weight of pencil I leave before painting.

Botanical illustration

Figure 20. Figure 21.

Critical assessment

- The most common mistake in tracing, which can happen to anyone, is putting the soft transfer graphite on the wrong side, so that no image comes through. Keep the masking tape on and check that the image is first reversed when you rub the soft pencil on the back, and then the right way up when you press through onto the watercolour paper.

- If you can't see the drawing after transfer, press a little harder. It may be necessary to use a softer pencil – try a 3B – to rub on the back of the tracing paper.

- If you press too hard, you can damage the surface of the watercolour paper, and actually engrave it.

- You can also damage the paper by being too vigorous when rubbing out the excess graphite, so use a soft, clean eraser to do this.

Watercolour

The watercolour techniques used in botanical illustration may differ from the more traditional methods used in landscape or looser styles. Here we will build up strong, vibrant, and luminous colours, while trying to maintain their delicate translucency.

Washes

The main technique is to build up wash after wash, building colour and form. There is no limit to the number of washes that can be applied (though the colour will be fully realised at some point) to a good quality paper, using good quality watercolours, as long as each wash is allowed to dry before the next is applied (1). Paint is applied in dilute washes, blending along the leading edge before it dries (2). Each wash acts as a practice for the next one, allowing you to check the colour and form. Each wash is stronger than the one before, and covers a smaller area, building up in the same way as contour lines on a map, but carefully blended together. The only way to create 'light' is by creating 'dark' elsewhere. Shadow and form are created by increasing the depth of colour where needed (8). Adding a cooler colour or increasing the amount of blue pigment into a green can enhance this. It is often useful to begin with one colour, and

gradually alter it to add subtlety and depth. By adapting the colour, and deliberately varying it, you can create a luminous quality to colours such as pink or purple.

Practise laying controlled washes, building up colour and blending the leading edge. Look at the light hitting your subject in order to understand how to paint it and to record where the highlights and shadows are. Try to use only the colour to create form and shadow (4 & 5). 'Shadow' colours, such as Payne's Grey, can make the work heavy and dirty, and should only be used with caution. Always record the reflected light on round subjects such as apples, as this greatly enhances the three-dimensional effect, and is even more important when painting groups of shapes, such as berries.

To record the light hitting the top of petals, add more colour to the base of the petal behind, so that each petal is defined by the one next to it. Thus you can continue adding layers of petals without making them progressively darker (7).

Glazes

A glaze is a dilute wash of colour that can soften detail and enhance or change colour. It should be applied only when the previous applications of paint are completely dry, and

care must be taken not to move or lift off the base colour (3). Always test what the impact of one colour over the base colour will be. Remember that you can only overlay a darker colour, not a lighter colour, as watercolour is transparent.

Dry brush

Dry brush is a technique used at the end of the illustration process to crisp edges and define detail. For this, a small amount of paint at the same strength and colour as the final wash is used to draw on detail, without creating hard lines or outlining the subject. It is not possible to do this with paint that is too dilute, as no definition can be achieved. This is another reason to mix plenty of each colour, and only dilute it as needed, allowing the main reservoir to dry out ready for the final detail and definition. To produce fine lines such as tendrils or stamens, no washes are required (6). Only draw these in with dry brush once or twice, as the more often you work on them the wider they become.

Composition

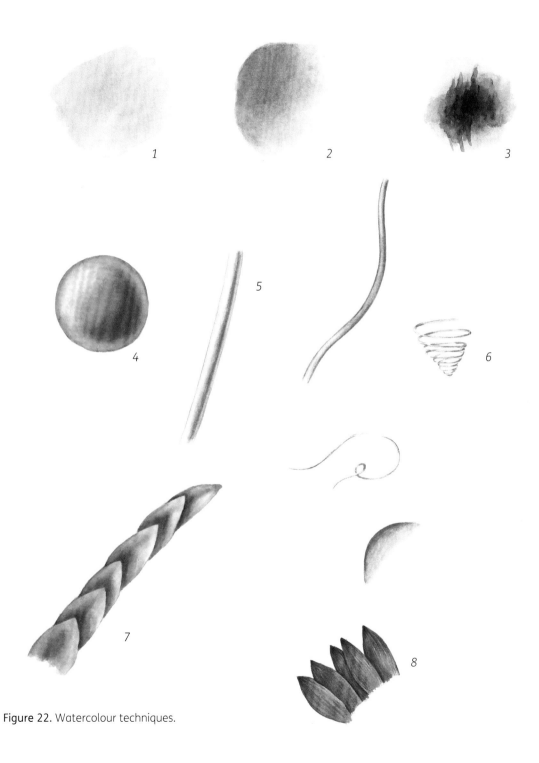

Figure 22. Watercolour techniques.

LESSON 1:

Accurate drawing

This will be the basis for all that you will be doing from now on. It may take you two or three hours to complete the drawing, but as you could be spending twenty hours on the painting, it is a wise investment in time.

Of all the things that can be blamed for a poor botanical illustration, a poor, weak or rushed drawing is the only one that can be clearly down to you, and no amount of technical tweaking at the final stages will make up for it. If something is wrong in the early stages, such as a leaf or a flower bending at an impossible angle or attached in an improbable way, correct it, and spend more time on the drawing next time. If the drawing is right, the painting will be so much easier. A well observed study showing an understanding of plant form, habit, shape and structure is the foundation for an accurate and detailed botanical illustration.

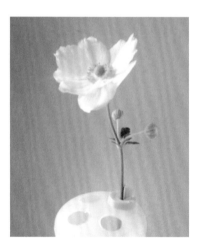

Figure 23. Anemone.

Prepare yourself as discussed above: sit comfortably with your sketchbook at a comfortable angle. Have your light source opposite your drawing hand, and try to maintain the same light for the duration of the illustration. Place your subject with care in the light and within arm's reach, and your equipment next to your working hand.

Have an HB pencil in one hand and a scrap of clean paper in the other, and begin. Shut one eye. The subject in front of you is three dimensional, and the paper you are working on is a two-dimensional flat surface. By shutting one eye, you limit your depth perception, enabling you to make a faithful rendition of your subject. Most right-handed people are right-eyed, while left-handed people tend to be left-eyed. To find your dominant eye, cover an object on the other side of the room with your thumb, both eyes open. Then, without moving your thumb, close one eye at a time. The object will appear to move more when seen through one eye than the other. The eye that records least movement is your dominant eye, so from now on the eye that you will be closing is the other one. In other words, pretend that you are looking through a telescope, as you will automatically use your dominant eye.

Now imagine a vertical plate of glass about a centimetre in front of your subject. This will mean that all the measurements you make can only be taken from a vertical and horizontal rotation on this plane. In other words, you are again limiting your depth perception, by not passing through your imagined plate of glass. All measurements will be taken from this plane. Any deviation from it will result in a disproportionate drawing. The aim is to produce an accurate, life-size drawing. All this is actually to make your life easier: if you reduce the size of your subject it becomes smaller and more fiddly; if you enlarge it, you are making more work for yourself; and by keeping to exact measurements you are less likely to make parts of your plant out of proportion, and more able to check and correct, if you do. Besides which, it is a requirement for publication in the *Kew Magazine*, and is an admirable target. Some people like to use a ruler or a pair of dividers to measure with, but I often note that they have a tendency to measure 'into' the subject, crossing into the plane of glass rather than rotating around it.

Offer your piece of paper up to your subject on the plane of the imaginary plate of glass, and take a measurement of the overall height of your subject. Do not draw the pot, the surface or anything other than the plant, as your work would then become a still life.

Botanical illustration

Figure 24.

Figure 25.

Using your piece of paper, record the height of the plant. Transfer this measurement to your cartridge paper, using an HB pencil, and maintaining the angle at which you took the measurement. Return to the plant and measure its overall width, checking that it fits within the cartridge paper.

Work around the plant, making a series of measurements that gradually become more detailed and informative. Begin to sketch in some lines and angles within this framework, gradually filling in detail, and adding more measurements all the time.

Figure 26.

Figure 27.

Always consider the central axis of your subject, be it the vein on a leaf, the centre of an apple, or through the middle of a twisting petal. Remember that you are recording a living thing, and bear in mind how it is constructed. Think of the flow of water moving along the stem, stalks, veins, etc., and allow your drawing to flow the same way, so that angles are soft and fluid. Continue taking measurements, cross-referencing them and re-checking the overall size, and remember the spaces that are

created between different parts of your plant and their relationships to each other.

Sit back and view what you have done, checking that it resembles the basics of your subject. Using an HB pencil, make gentle marks that can be easily rubbed out if incorrect, and won't scratch your paper like a harder lead or leave lots of graphite, as a softer pencil would. Now is the time to correct basic mistakes: it is much easier

at this stage, when you have only invested a few minutes in your drawing, than later, when you have painstakingly recorded every detail of serrations and veins. Work over the whole drawing, checking for shape, form, pattern and balance, and rubbing out your first, sketchy lines. Think about the form you are recording. If you cannot see how a petal is attached, move so that you can, and then return to your base. By making the lines flow, the structure will be correct, with petals firmly linked and the stem properly attached.

When you are satisfied with your drawing, swap the HB pencil for a fine, sharp 2H pencil. Work over the whole drawing, rubbing out a tiny bit at a time, re-measuring, checking and refining the lines to one 'perfect' line. Keep looking at your subject, observing and recording every detail. Consider where lines come from and go to, in order to create a perfect line drawing of the plant in front of you, with no discrepancy or ambiguity. Recording the intention of the line will greatly improve the quality of your drawing, with the smallest alteration of the movement of a line having great impact on the overall illustration. When working in paint, the accuracy of your drawing will be tested, and you will have enough to concentrate on without having to worry about the underlying drawing, or question its

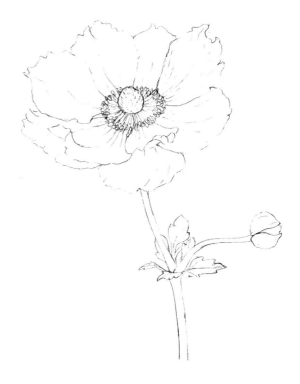

Figure 28.

accuracy. Time spent tidying and refining the drawing will reward you tenfold while you are working in watercolour. Make sure your drawing reflects the nature of your subject, so that a daisy is fine and delicate, while a conker could be drawn with a more solid line. The drawing is now ready to be transferred to watercolour paper, inked in for a line drawing, or worked up as a tonal pencil study.

Critical assessment

- If the drawing does not look like the plant, blame the plant: it has probably moved. A living subject will be moving constantly, and a flower will rotate to follow the light source. Try to stay with your original measurements and observations.

- If the drawing is out of proportion, the measurements are probably more accurate in one dimension than the other. Usually, people find the horizontal measurement easier. Go back and re-check, starting with the more accurate measurement and rotating at the same distance.

- If the drawing is heavy and undefined, or smudgy and hard to read, use a harder, sharper pencil. Check the quality of your paper.

- If the stem appears to be detached from the flower head, ensure that your original lines bisect the flower following through from the stem, and that the width of the stem is sufficient. Always allow imagined lines to continue through flowers and leaves to ensure correct attachment.

- If the petals appear to be detached, work out from the centre of the flower to create a radiating system of petals.

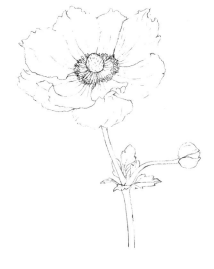

LESSON 2:

A leaf

For this lesson, we will skip most of the drawing to concentrate on identifying and mixing colour, and laying washes to create an accurate watercolour illustration of a leaf.

Select a leaf. Try to choose an ordinary green leaf such as an apple, walnut, or silver birch leaf, one that clearly shows the veins and structure. Avoid a multi-coloured or variegated leaf for this exercise, or one with deep shine like holly or ivy, which require different techniques. Make sure the leaf is clean and dry, and place it on your watercolour paper, positioning it with care, not in the middle of your paper, not too close to the edge, but consider that you may want to include the other side, or another leaf; or mount and display the finished illustration. Hold the leaf carefully, and use a 2H pencil to draw around it, including details and serrations. Draw along one side only of the stalk, otherwise it may be too thick. Lift off the leaf, and use a small piece of masking tape rolled over to attach it to the side of your easel or paper, at the same orientation as your drawing. Now add detail to your drawing,

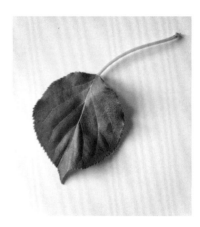

Figure 29. Apple leaf, actual size 15.5 cm tip to stalk.

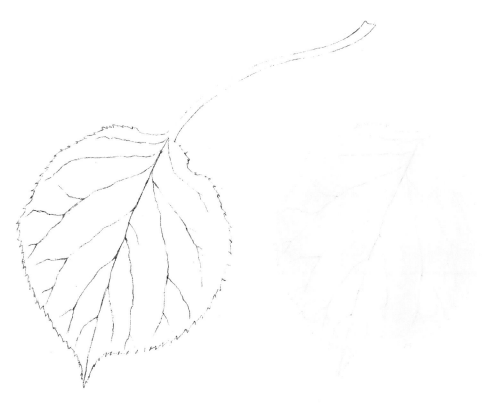

Figure 30.

Figure 31. Here I have used Lemon Yellow and Cobalt Blue.

starting with the midrib, and allowing the minor veins to branch off fluidly. Correct any mistakes or discrepancies in the outline, and finish the stem, noting the correct width. If the leaf is very large, or your confidence is low, use an HB pencil first, and measure the distances and angles, as you did in the first lesson, before correcting and refining the line. If you have inadvertently left too much graphite on the paper, gently erase the excess with a soft eraser, until you have a clean and barely visible drawing, so that when you have finished the painting, the pencil will be invisible.

Set out your watercolours, palette, brushes, kitchen paper and water pot, and a scrap of clean paper to test the colour on and protect your work from your hand. Look at the leaf and decide on the lightest colour, usually the midrib, which is often the same as the stalk. Mix this colour using yellows and blues, using your mixing brush. A light Lemon Yellow or Linden Green, mixed with a delicate blue such as Cobalt, will produce a fresh, delicate green. A heavy, 'eggy' yellow like Cadmium mixed with a stronger blue like Ultramarine will produce a deeper and darker green. Play with

Botanical illustration

your colours: experiment with the mixes, trying different combinations. Some colours may behave less well than others. Ultramarine has a tendency to granulate and separate, so stir the paint regularly or you may find your mixed colour changes as you paint. Start with the lightest, brightest colours, because watercolour is translucent. You can lay darker colours over light, but not the other way round. Mix the base colour at full strength in one of the wells of your palette, and offer it to your leaf on a scrap of paper to compare. Adjust if necessary. Try to mix enough of each colour so that you need not re-mix. This way you should be able to keep using the same 'mix' at increasing strength. When you are happy with the colour, bring some of it forward to a sloped well, and dilute with clean water. Check the dilution on the scrap of paper, and using a good size brush, such as a size 6, apply a delicate wash all over your drawing. The aim is to lay a flat wash, evenly, so that any light and dark areas are created intentionally. To that end, you have to carry a little bit of pigment in a lot of water. By mixing enough paint, and diluting the correct amount, if your brush runs out mid-stroke, you can quickly and easily get more of the same colour and strength paint. Only paint on an area where you can access the edges before they dry out, as without blending, you will get a hard line. If you need to stop, either stop at a hard line or edge within the illustration, or wash your brush, dry it by running it over the kitchen

paper, and soften the leading edge, washing it away to nothing. While painting, remember: the smaller the area, the stronger the paint.

Allow each wash to dry before applying the next. Failure to do this will damage the paper (at worst, making a hole), could lift off the previous wash, and will result in an uneven and patchy appearance. Each wash you lay can be stronger than the one before: because the area may be smaller, the contrast will be less, and your confidence should be growing. When the first wash is dry, bring more of your mixed colour forward to strengthen your dilution. Lay another, stronger wash of colour all over until you are happy that the base colour is sufficient. Having allowed this wash to dry, bring more of the original colour forward, and apply a graduated wash to the darker areas of your leaf to create form, typically at either end to lift the centre and make it roll slightly. To do this, apply the slightly stronger colour to the area, wash and dry your brush, and blend along the leading edge, softening the paint to make a smooth transition, but do not over-work the area.

If you find the paper becoming patchy and uneven, check that the paint is not too strong, that your brush is big enough, and that you have let the paper dry out thoroughly. If your leaf has undulating edges, paint small wedges of colour along that part of your painting, and blend both edges, remembering to only paint

Figure 32. This was also done using Lemon Yellow and Cobalt Blue, but with a slightly stronger wash.

Figure 33.

an area of a size where you can deal with the leading edges before they dry and leave a hard line. Do make each wash count by ensuring it is stronger than the one before. Provided each wash is allowed to dry, there is no limit to the number of washes you apply. Each wash should, however, be a practice for the next, stronger wash, in that you are trying to build colour, shape, and form. If it works, repeat it at a stronger level; if not, alter it until you are satisfied. Build up the colour until you have reached the darkest part of the lighter colour.

When you have enough of the base colour down, mix the colour for the blade of the leaf, the colour between the minor veins. Mix enough of this colour to complete the piece, and to cover every base, note down the colours you have used. Again, test the colour by painting on your scrap of paper at full strength, and holding it up to the leaf. Now take some of the colour forward and dilute it with water. This time, apply a light wash down either side of the midrib, and extend the wash out to the edge of the leaf. Use the pencil line

Botanical illustration

Figure 34.

Figure 35.

as the edge for one of the washes, leaving the vein in the base colour. Allow to dry. I have added Cadmium Yellow and more Cobalt Blue to the base colour.

One side of the midrib should be darker than the other, because of the way the light falls, so apply a wash along the shadow side, and blend into that half of the leaf. Enhance the form that you recorded in the base colour, carefully blending and softening the edges, and creating areas of light and dark.

By now you may be beginning to lose your pencil lines for the minor veins, so using a smaller brush such as size 0, and strengthening the paint, apply bands of colour between the minor veins. Use your pencil line as one edge and allow small spaces between them, so the minor veins are left as negative, tapering towards the edges of the leaf. Your illustration should be beginning to resemble your leaf, with the paler midrib showing, and the minor veins formed from the top colour, giving more prominence to the midrib.

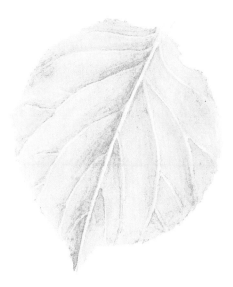

Figure 36.

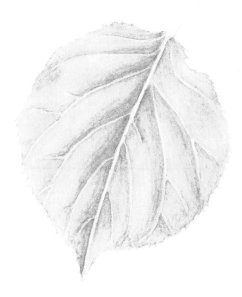

Figure 37.

Look closely now at the lighting. It may help to fold a piece of paper into a concertina, and see how the light falls on it: the paper is all the same colour, but the shadows alter the depth and tone of the colour. This is your next task. Make the paint stronger – again, the smaller the area, the stronger the paint. Starting at the midrib, apply paint along the shadow side of the smaller vein and blend away, leaving a firm edge along the pencil line. Move along one half of the leaf, one minor vein at a time, tapering the vein as it reaches the outer edge of the leaf. Do the

same for the other side of the leaf, carefully observing the light.

Continue building up the colour and form, by adding washes and translucent glazes, still allowing each wash to dry before applying more paint. Define the other side of the minor veins, if necessary, to create raised areas between them.

Botanical illustration

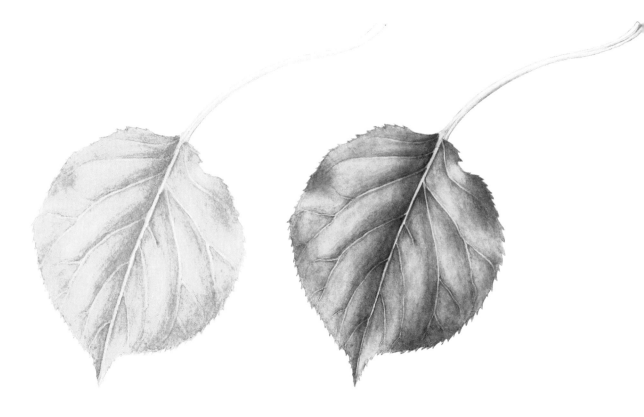

Figure 38.

Figure 39.

Check the colour as you go, and work on decreasing areas of the leaf in a strengthening colour. Sit back from your work and check it against the leaf for colour, shape and form. Try turning the illustration upside down, to get a different view of it. If necessary, lay down a translucent glaze to correct the colour or rebuild form. Polish the surface of dry paint with a clean, damp brush to remove unwanted texture or discrepancy in the washes, taking care not to over-work the area or lift off the colour.

Finally, add detail and definition using a size 0 dry brush to crisp and enhance the illustration. Remember to define the outer edge of the leaf, showing the serrations without leaving a harsh outline. This level of observation and detail is what will make this work a botanical illustration, rather than a flower painting. By now, you will be drawing in final detail with your brush, remembering that the smaller the area, the stronger the paint, but be careful not to outline your illustration.

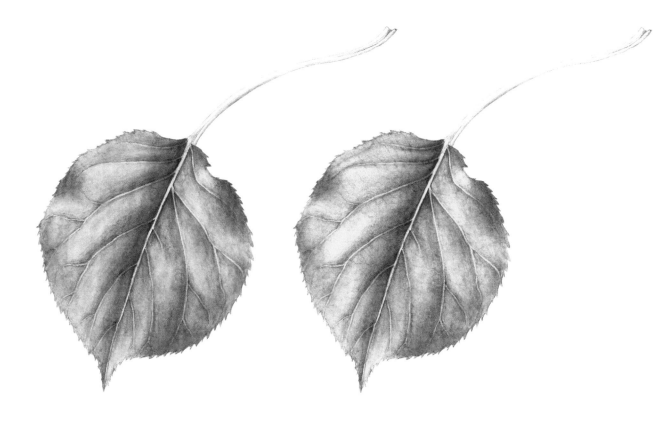

Figure 40.

Figure 41.

Be wary of putting in too much detail in the form of surface texture. You can sometimes put in every tiny vein, and in doing so destroy the overall effect. It can be effective to paint in the minor veins, faintly, and leave to dry, before polishing the surface with a slightly damp brush. Remember to allow for a tiny amount of interpretation of what you are seeing: you are telling the leaf's story, and allowing a part of you into the illustration. If five illustrators painted the same leaf, the images would not look the same.

This final detail should be an enhancement of the previously applied colour, and should be laid with a specific and varied density to promote definition without a hard line, which would deter from the form you have been building up. Add form to the stalk by adding more colour to one side of the stem, and delicately defining the other. If there are any other colours on your leaf, such as reds along the stalk, or in the veining, now is the time to lay on a translucent glaze of colour, often Alizarin Crimson. Test the colour, both on its own and also over a sample of the green you have used.

Critical assessment

• Each leaf must be carefully observed and painted. No two leaves are the same, even on the same plant, as the angles will vary or the light will hit them differently, or their position on the plant will affect how you see and record them. Each leaf must be looked at carefully, and you will find that different techniques work for different leaves. Observation is the key.

• The biggest mistakes in watercolour are due to not allowing each wash to dry thoroughly, especially in the early exercises, where you are only painting one part. As you move on to more complicated plants, there will be multiple leaves and flowers to work on, giving you plenty of time to work around the illustration, letting each section dry. Be patient. While you are waiting, mix the next colour, or examine your leaf under a magnifying lens, see how other people have painted leaves, or make a cup of tea – remembering not to leave it within reach of your water pot.

• If you have laid down too much paint, or the leaf has become heavy and over-worked, carefully lift off some of the paint using a damp brush and a piece of blotting paper. Be careful not to overstress the paper: wait for the paint to dry before correcting the area. Major mistakes or splashes can often be removed with magic sponge. Lightly dampen a small piece of magic sponge and rub over the mistake gently, cleaning as necessary, and blotting with blotting paper to prevent over-wetting. You may see small particles coming off – hopefully only from the sponge, which gradually disintegrates. If the paper is damaged, allow it to dry completely, then burnish the area by placing a piece of tracing paper over it and rubbing with your fingernail to smooth the surface. You can then go on to correct and redefine the area.

• If the washes are not clear and translucent, and appear patchy, consider your technique. Apply the paint and blend along the leading edge with a clean, damp brush. The first washes are about form, and laying colour smoothly, so that detail can sit clearly on top. If you are constantly touching wet paint, you will lift it and make the colour patchy. Do not work into the wet paint, trying to pull it out, but blend along the leading edge. Remember to control first the

amount of paint on your brush, then how damp the clean brush is when blending. If it is too wet, you will just spread the wash out equally, and will not build up any contrasting areas of light and dark.

• If the veins have lost detail and definition, use a clean, damp brush to gently lift off the paint, leaving a paler line.

• If the leaf as a whole appears flat and lacks form, use delicate glazes of colour along the midrib or sections of the outer edges, blending them into the rest of the leaf.

• If the serrated edges don't look attached, use a damp brush to carefully blend them into the rest of the leaf. Make sure to always work them into the leaf from the first wash onwards.

• If the colours have become dirty, you may have over-worked the area and stirred the colours into each other. Allow each wash to dry, especially if using a second colour.

• If you have created fish bones with the minor veins, check your drawing. They should be flowing gently out from the midrib. Follow your drawing, making sure you allow for the curvature of the minor veins, and 'stepping' them slightly, as they very rarely branch directly opposite each other.

You should now be looking at a well observed and accurate representation of your leaf. Well done! The next time you paint, remember all the stages of this lesson, and don't miss out any washes, or try to take short cuts. Take your time over each illustration, and enjoy every challenge and every moment.

LESSON 3:

An apple

This lesson is all about illustrating a spherical three-dimensional object with a shiny surface, and using more than one colour. For this we will go through the whole process of drawing in your sketchbook, transferring your image to watercolour paper, and then laying controlled washes to build colour and form, correcting the colour with glazes and finishing the illustration with dry brush.

Select an apple. Here, I have illustrated a Cox. If you are buying fruit, watch out for anyone examining their purchases more closely than usual: they might well be a botanical illustrator! Only someone deeply interested in colour, shape and form is going to be looking that carefully.

Place your apple on a piece of white paper on your drawing side (i.e. away from your working hand). Twist and turn your apple; consider its shape and colour. It may help to wedge a pencil under the front to tilt the apple slightly, so that you are looking at it in semi-profile rather than directly onto the top. Using your HB pencil and a scrap of paper, begin marking the dimensions on your cartridge paper, and sketch in the shape. Draw a line through the centre of the apple to

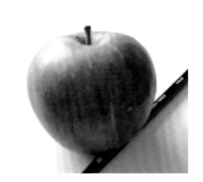

Figure 42. An apple.

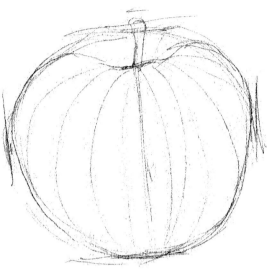

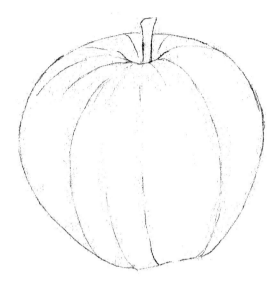

Figure 43.

Figure 44.

record the angle of the axis. Rounded shapes can be difficult to capture, so sit back and look to see if you have distorted the image. It is often easier to record horizontal measurements than vertical measurements, so check your proportions: the drawing should look vaguely rounded. If you find it is distorted, check your more accurate measurement and rotate the measuring paper at the same distance. Turning the drawing upside down may help to identify any problems. Remember to hold the scrap of paper at a near-vertical angle, to restore the three dimensions of the original. Draw in the stalk, checking the position on the 'shoulder' of the apple. Now draw in the surface lines, which are often a different colour. Think of these lines curving over the surface of the apple, and

picture the shape you would get by cutting out a quarter section. The lines must begin from the base of the stalk and continue under the base towards the flower end, even if you can't see the base, as this properly describes the surface. A small observation like this adds to the three-dimensional effect, and while these lines will not be transferred to the watercolour paper, you will refer to them, and when you apply the paint, knowledge of the movement will be evident.

Now use a 2H pencil to tidy and refine the line, rubbing out the coarser HB drawing as you go. Remember to refine the line, not reinforce it. Check the measurements again as you work around. By now, you should have a perfect line drawing of your apple, detailed, accurate and

Botanical illustration

ready to be transferred to your watercolour paper. Now would be a good time to consider the surface of your watercolour paper, and how much damage you have spared it by drawing on cartridge paper, and you also have your working drawing to refer to, or to re-use if it all goes horribly wrong.

Transfer the drawing onto watercolour paper (see page 34), tracing only the outline, shoulder and stalk. Tidy, check and refine the line, and ensure that it is not too heavy, so that the graphite can eventually be lost in the painting.

When painting, make sure everything is clean: water, paints, palette, kitchen towel and brushes. Mix the base colour of the apple. Often this is a green or yellow colour. Try to see under the surface colour, which may be red, and remember that you can lay darker colours over light, but not lighter colours over dark. Mix plenty of paint in the deep well of your palette, and test it on a scrap of paper at full strength, then bring some forward into the front well, and dilute it for the first wash. Use a big enough brush, such as a size 6, which will hold plenty of paint. Look at the light hitting the apple – squint if it helps – and identify the brightest highlight or area of shine. It may help to place a white table-tennis ball next to the apple. This should show the form in terms of light and dark, without the confusion of colour. It is often helpful to try to break the form down

Figure 45.

into a simple white shape to identify light and dark by using a blank model.

Apply a light wash of the base colour over the whole apple, except for the main area of shine. This may mean that you have to work on one section at a time, blending the paint away along the leading edge and polishing around the shine, controlling the wash, and laying it flat. Then move on to the next area. As you have the paint mixed and at the correct dilution, this is easy to do. You can paint over the stalk at this time. Here, I have mixed Linden Green (you could use Lemon Yellow) and Cobalt Blue, and have left a ring of light around the stalk, which will form the basis of my shine.

Figure 46.

Figure 47.

Next, bring some of the colour forward so that you increase the strength of your wash. Keep checking the colour against the apple. I have added a tiny amount of Cadmium Yellow into my mix, to stop the colour becoming too acidic. When the first wash has dried, apply a second, stronger wash over the darkest areas of the apple, in curved vertical bands, using the lines you recorded in your working drawing for reference. If you need to, you can paint through part of the shine, to reduce the area, as you increase the colour of the apple. Remember only to work on an area that you can access before the paint dries, and polish the edges with a damp brush to blend the colour. Allow the paint to dry after each wash.

This should give you an idea of where you will be painting to build up the colour and form. Each wash you do will be in a stronger colour, applied to a smaller area. You could think of the paint as contour lines on a map, but carefully polished to produce a smooth surface. The only way to make the highlights and shine brighter is to make everything else darker.

Now apply a wash through a horizontal band above the bottom of the apple, and blend away both the upper and lower leading edges. This will record the reflected light from the paper beneath the apple, and will help to produce a three-dimensional image.

Botanical illustration

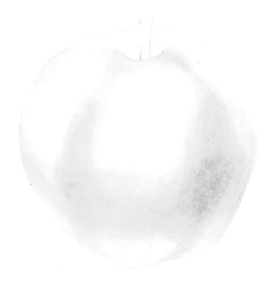

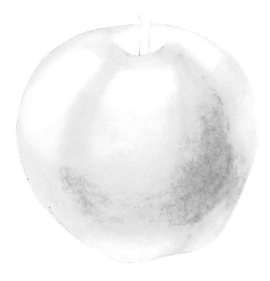

Figure 48.

Figure 49.

Still using the large brush, work in alternate horizontal and then vertical bands, blending away the leading edges and following the curvature of the apple, as recorded in your working drawing. Check the colour as you apply it, and correct it if needed; you may need to add more blue to the colour to increase the weight of the form, or more yellow to the brighter areas near the top. Ensure each wash is dry before applying the next.

So far, all the paint has been in the base colour, and should be smooth and free from lines and texture. The illustration must be fully realised in this colour before moving on to the final colour, or it will become muddy. By now, the washes could be linked, still curving over the surface of the apple, and will be forming a J shape, with the darkest area opposite the brightest highlight, and secondary shine showing beyond that. Remember to increase the colour to darker parts of the outside of the apple, where it becomes more concentrated as the surface curves away. Blend this into the main body colour, taking care not to leave an outline.

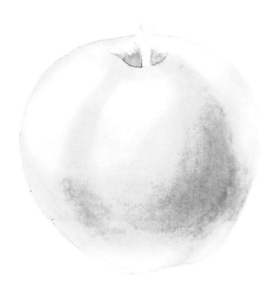

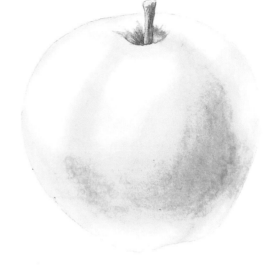

Figure 50.

Figure 51.

Now paint the stalk, using a mixture of Burnt Umber with a little Cobalt Blue to make a soft brown. Even though the area is small, make the first wash of paint dilute, so that you can add form to the subsequent layers. Mix the colour for the area around the stalk, which if often a grey. Try some Yellow Ochre with a touch of Payne's Grey. This should be applied in the curves described in your working drawing, and can usually be left unblended, creating hard edges as it meets the base colour.

Look carefully at the light hitting the stalk and observe the lighting in the centre of the apple. The apple will be darker than the stalk where the light hits the stalk, and in contrast, lighter than the other side of the stalk, which will be in shadow. This may sound trivial, but it is this level of observation that makes a fine botanical illustration. Work on the stalk and centre at the same time, as they impact on each other so closely. Adding the stalk and centre at this stage gives a real feeling of body and mass to your illustration. The grey centre will form the movement for the application of the top colour, which you can now begin.

Botanical illustration

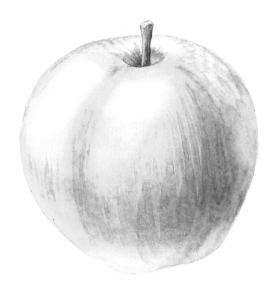

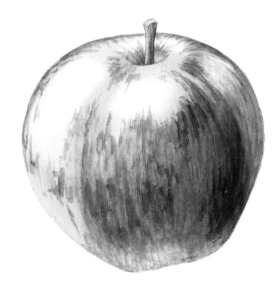

Figure 52.

Figure 53.

Check that you have built up the base colour enough, and that the form is fully shown. Once you start using the top colour, you don't want to return to the base colour, which can be lifted and mixed in, causing the two to become muddy.

Mix the top colour of the apple, which forms the surface and final colour. This is often a bright red, such as Cadmium Red, building to a deep red such as Alizarin Crimson. Test it on your scrap of paper, then try it over the test area you used for the base colour. Hopefully the combination of the two will create the final colour; if not, try again. Dilute the first

bright red wash to a manageable level. Here, I have used Cadmium Red, mixed with a little Cadmium Yellow, in a very dilute wash, to work out the coloration and curves. There is enough to concentrate on, laying this glaze over the curved surface, so do not worry about the depth of colour here. Still using a large (size 6) brush, lay the red glaze and lift off your brush through the areas of shine to keep them white for now.

If your apple has areas of solid red colouring, apply the red as a wash to that area, and blend away the hard edges as it meets the more variegated colouring, taking care not to disturb

the base colour. If the apple is delicately patterned all over, apply the paint to small sections at a time, working vertically down the curves of the surface, and referring to your working drawing. Use a clean, damp brush to soften the edges of the pattern a little, but take care not to move the base paint. Continue around the apple, still avoiding the areas of shine, and working in vertical curves. Some people like to use 'wet-into-wet' if the colouring is very dappled, but it is less controlled. Try a small section: lightly wet the area, and stipple in a small amount of stronger paint, allowing it to bleed out, softening the effect.

Next, strengthen the colour, and add more paint to the areas that have a deeper base colour. This will confirm the form. Continue strengthening the colour, checking both colour (you may need to add the Alizarin) and form. Switch to a smaller brush (size 0) for the smaller areas. Make the paint more yellow in places, returning to the first red wash for delicately coloured areas. Increase the red where you have used more of the green base colour to depict the shadows. Look critically at the shine. If it is too stark and white, reduce it by washing the base colour over some of it, then incorporate the top colour, or soften the edges to reduce the size. Blend in the red where it meets the green, softening the transition areas without losing the delicate dappled effect. Carefully

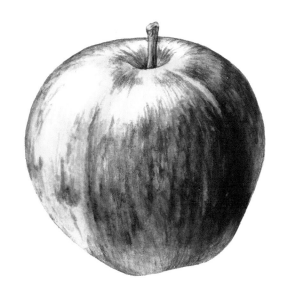

Figure 54.

blend the two where the base colour shows through the surface colour, making sure you are not adding unwanted texture or weight. Turn the illustration upside down, or look at it in a small mirror, to check balance and form, and give it a critical appraisal. If you are happy with the result, add detail and definition to the illustration using a dry brush. This should be in the final colours that you have used, and at the finished strength, varied as you move around the work. Consolidate the outline, taking care not to create a hard edge, as this will kill all sense of form in the way a black line does. Use it to enhance and define the edges, bringing them into perfect clarity.

Now sit back and admire your work. Everyone is his or her own worst critic, which is a good thing. The day you are really pleased with a piece of work may be the day you give up, as there is nothing else to achieve. Instead, look for the merit in what you have done. Admire the drawing, or the colour, or the way the shine is depicted. Well done!

Critical assessment

- If things really have gone wrong, don't despair. If you have over-worked the surface and lost the shine, dampen your larger brush and carefully use it to re-wet the area where the shine should be. Gently 'scrub' with the brush, then lift off some of the paint by pressing a clean piece of blotting paper onto the dampened area. This can produce a good effect, but wait until the paper has dried thoroughly before correcting the area of shine, as often more paint is removed than is desirable. For a more severe correction, use magic sponge: cut a small piece, dampen it slightly, and use it to gently scrub over the offending area. Blot with blotting paper to dry out, and again, wait until the paper is dry before correcting. Do not be tempted into over-wetting or over-scrubbing the area, as you can badly damage the paper, from which there is no recovery. When the surface has dried out, burnish it carefully with a piece of tracing paper laid over the area, and the back of your fingernail, before correcting with dry brush.

- If the form is not fully developed, it is probably because the base colour was not fully realised before overlaying the glazes of top colour. This is something that takes experience and practice.

- If heavy washes have left 'tide lines', dilute the first washes so that you can control them and blend in the leading edges before they dry.

- If too much texture has built up, make sure each wash is dry before moving on to the next one, and blend each wash carefully, using a damp brush to polish the edges without disturbing the underlying paint.

- If the shine has become lost, take control of the first washes, analysing the light and dark carefully. Correct with blotting paper or magic sponge.

- If the colours have become muddy, change your water regularly, especially when you change colour. Take care not to disturb the base colour when overlaying the red glazes.

- If there is too much texture and pattern, polish and blend hard lines away. Think of the polished surface of the apple. Use a bigger brush to create a softer effect. A small, fine brush can leave fussy detail rather than surface colour.

- If the edges are not crisp, use the base colour to carefully re-define them, then overlay the top colour, taking care not to leave a heavy outline.

- If the stalk does not stand out, lift out and correct the central area, then recreate the form carefully, recording the light and dark, and the contrast between the stalk and the apple.

- If the form is not consistent in the top colour and pattern, make sure the top colour continues the form and enhances the base colour, being darker where it is darker, and lighter where it is lighter. Ensure the pattern is applied in curves, following your original observations as recorded in the working drawing.

LESSON 4:

Mushrooms

This lesson is all about restraint and control: how to lay delicate washes of 'Botanical Grey' to depict shape and form.

Arrange one, three or five pale button mushrooms (think of odd numbers for botanical illustrations) on a piece of white paper. Consider the angles and spaces, whether they are touching or too far apart. A line of three can look contemporary, but ensure good spacing between them: too much space and they don't relate to each other; too little, and they are overcrowded. Arrangements of three in an uneven triangle can work well, with one set apart from two overlapping slightly. Beware of close encounters: shared or mutual lines formed by two objects just kissing can create harsh and distracting shapes.

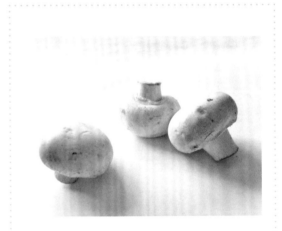

Figure 55. Mushrooms.

In your sketchbook, begin your drawing as you did for the apple in Lesson 3, using an HB pencil and a scrap of paper to measure with. First, measure across all the mushrooms, incorporating the whole composition. Then break it down into the individual mushrooms, measuring the spaces between them as well. Place a line through the central or vertical axis of each mushroom, to get the angle through the cap and stalk right. Measure the height of the stalk and the cap, and ensure that they add up to the overall height.

Figure 56.

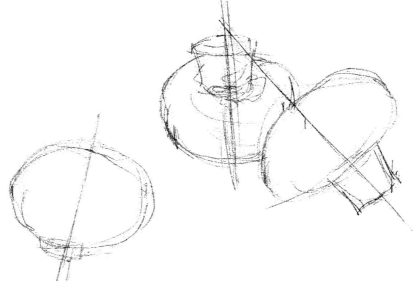

The mushrooms should be looking roughly symmetrical. Turn the drawing upside down to check the shape. The ellipse created by the end of the stalk – if it was cut truly, though it may be cut at a slant – will be repeated at the junction of the stalk and cap, and will show itself in the movement of the end of the cap. Check that the two look properly connected, and are well centred through the axis you drew in first.

Figure 57.

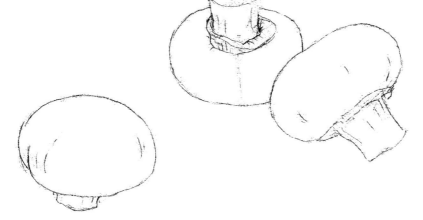

When you are satisfied with this initial drawing, use a fine, sharp 2H pencil to refine the line, rubbing out any inaccuracies and perfecting the line, not re-enforcing it. Keep the drawing delicate, as this reflects the nature of the subject matter. This working drawing can record small details such as feathering on the cap and fine lines on the stem, which will help you understand the form and structure, but do not transfer them.

Botanical illustration

When you are satisfied with the whole study, transfer the drawing to your watercolour paper. If you want to make changes to the composition, or the placing of the mushrooms, trace them separately onto small pieces of tracing paper and rearrange them on the watercolour paper, then remove them individually to rub the graphite on the back prior to tracing, then continue as before.

As you will be using pale colours to paint the mushrooms, make sure that you remove enough of the graphite before applying the first wash. Redraw the lines in a 2H pencil, referring to your drawing and the mushrooms, before rubbing out the excess, until you can only see a faint pencil line that will eventually be lost in the painting.

Make sure that your palette and water pot are clean, and there is no contamination in your watercolours. Mix a 'Botanical Grey' using a little Cobalt Blue, Burnt Umber, and Payne's Grey. The blue gives you clarity, the brown gives warmth, and Payne's Grey gives a neutral shadow. Test on a scrap of paper and compare it to one of the mushrooms. If you were painting a white flower you would increase the amount of blue, but for mushrooms you will need more brown. You are trying to mix a warm, neutral colour that you can use to create the form and shadows. Too much grey and it will look dirty, too much

blue and it will look cold, too much brown and it will just be brown, so test at a reasonable strength, and then dilute some of it massively and test it again. The first dilution for the first wash should be little more than a slight smear on the paper.

Look closely at the mushrooms and prioritise the form in terms of light and dark. Remember that a table-tennis ball may help to decide how to create the form. As with the apple, each mushroom will have an area of highlight nearest to the light source, and an area of shadow away from it, with reflected light beyond this. Leave most of the mushroom as white paper at the start and gradually paint into it. As the colour increases, so will the contrast, and the white may need to be given a glaze of colour later. Use the bigger brush (size 6) to apply a delicate wash to the darkest area you can see, taking care to blend the leading edge away. Harsh lines will show, as there will be no opportunity to obscure them with later washes, the whole illustration being very pale. (White flowers do not take very long to paint, but in terms of thought and delicate application of colour they can be very demanding.) The point where two mushrooms touch will be the darkest point, so begin by painting this, blending the leading edge away. Most of the surfaces will not be receiving any paint, leaving the paper the palest part of your mushrooms for the time being. Consider

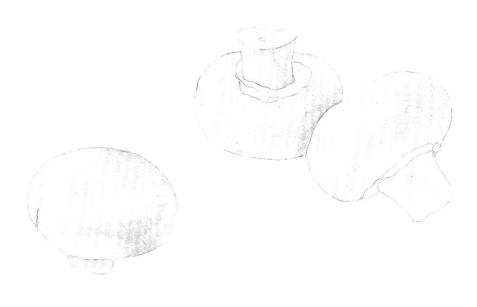

Figure 58.

the darkest side of a mushroom, that which is away from the light, and the reflected light that will add to the three-dimensional effect.

Now work in crescent-shaped washes, alternating vertical and horizontal bands of paint which describe the surface of the mushroom, as you did for the apple in Lesson 3. These delicate washes record the form and the colour. Allow each wash to dry before applying the next. Make judgements about which is lighter and which is darker. Paint the stalk, observing the shadow cast on it from the cap. Remember to show the reflected light on the stalk. Generally, when two objects are adjacent, the one in front has more light on it, throwing a shadow onto the one behind. The stalk will be darker away from the light, with some reflected light beyond, which means that the cap can be shown to be darker beyond that. Make the depth of colour on the cap continuous, so that it passes evenly behind the stalk.

Botanical illustration

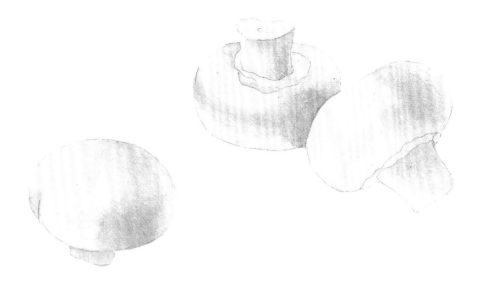

Figure 59.

The next washes will be slightly darker (stir
the mixed paint, and bring more forward for
dilution), but over a smaller area, reinforcing
your original observations. Still allow plenty of
white paper to show. Continue building up the
colour, shape and form, allowing each wash
to dry, and gradually working over smaller and
darker areas. Check the colour as it increases,
making sure it is not too heavy, too grey or
too brown.

Figure 60.

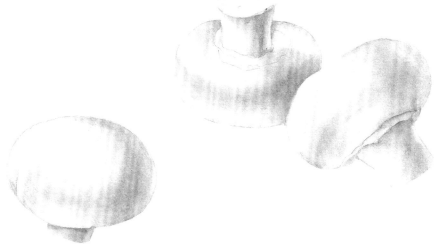

You may now need to reduce the light areas as you bring up the colour, as the contrast between light and dark may be too great. The edges of

the mushrooms will need to be consolidated, so add more colour as it often accumulates as it passes over an edge, but do not make an outline.

Figure 61.

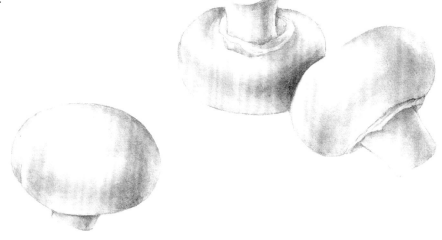

At this point, sit back, turn the illustration upside down, and check that you have correctly recorded the form and light.

Use a smaller brush (size 0) to increase colour and form, and to pick out smaller detail.

Botanical illustration

Figure 62.

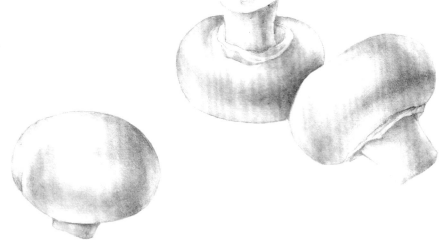

When you are satisfied with the form, consider the colour. So far, the work has all been done in monochrome. Now mix a little paint to depict the surface colour. This may be a little of your base colour, with a touch of Yellow Ochre for some areas. Other places may need a little extra Burnt Umber, or you may choose to warm up the colour with some Burnt Sienna. Use this as a very dilute glaze on the appropriate areas, making sure that you leave plenty of the mushrooms white or at least very pale.

Figure 63.

Now move between the Botanical Grey from the first washes, and the warmer colour from the colour glaze to add the surface detail, such as small marks, dirt, or the very delicate bits of feathering that appear over the cap, and fine lines on the stalk, referring back to your working drawing.

Make sure this detail enhances the form, being light in the shine and darker in the shadows. Finally, check that the form is fully developed. Finish using a dry brush with paint at the same strength as the final washes to add detail and definition to the study. By strengthening the depth of the dry brush detail, and drawing with the stronger 'grey' limited to tiny areas, it is possible to make the 'white' appear whiter than the paper. Remember not to outline the mushrooms, but to crisp and define only where needed.

Critical assessment

- The degree of observation and the length of time elapsed since you began work will probably mean that your mushrooms have deteriorated, and may have changed colour. If you think you may have made them too dark, compare your illustration to a fresher specimen from the fridge. If necessary, lift some of the colour off with blotting paper, as before.

- If the mushrooms look grey and dirty, check the first washes. If the colour was too grey, warm it up with the brown. If the colour is too heavy, it should have been diluted more. If the mushrooms appear too cold and 'dead', you have added too much blue. Try lifting off some of the colour in the lighter sections, to recreate the form and delicacy, using either blotting paper or the magic-sponge technique. Allow to dry before retouching with more restraint. Remember that the purpose of this exercise was to make you think about form and delicacy: laying controlled washes with minimum colour to create form.

- If the mushrooms still look flat, this may be down to the detail, which needs to be applied carefully and in line with the form created in the previous washes. Definition and detail that fail to complement the form can act as an outline. Make sure the detail records light and dark appropriately.

- If the composition looks unbalanced, turn the illustration upside down to see it from a fresh viewpoint. Restore form and check that all the mushrooms are worked up to the same level.

LESSON 5:

Pencil study

This lesson is not just about selecting and using the appropriate pencil: the main aim is to help you to identify light and dark, and to record texture, tone, shine and form.

A fully worked up pencil study can also be an informative botanical illustration.

This work can all take place in your sketchbook, though if the paper becomes too marked or dirty, the drawing can be transferred in the usual way. Hopefully, you will be working on a good quality cartridge paper that will not let you down. A heavily textured paper may interfere with the quality of the line and tone you are trying to create.

Choose an onion and place it on a piece of white paper. Twist and turn it to show it at its best and most 'oniony'. You may need to wedge it in place with a pencil or a small piece of Blu-Tack. As with the apple, you do not want to show the onion from above. A semi-profile is best, so that you can see the neck, where the stem meets the shoulder,

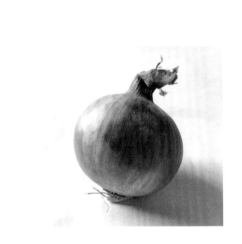

Figure 64. An onion.

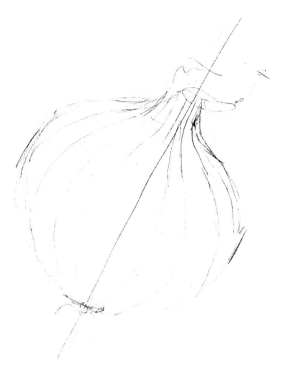

Figure 65.

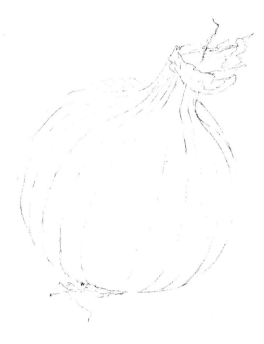

Figure 66.

and the roots. Now consider the angle of the axis through the centre. Record this angle as a straight line, using an HB pencil. Measure the height and width of the onion, recording the difference between the stem and the shoulder. Keep checking the overall measurements – remember that round shapes can be tricky, so rotate your measuring paper on the 'plate of glass' (see page 41) at the same distance each time. Think about the domed onion shape you are trying to achieve. The test of the outer shape comes next, when you draw in the veining. Think about the lines being stretched out straight and then pushed together like

a paper lantern, all coming together at the ends and moving out gently over the surface, describing perfect curves. These lines will be furthest apart above the centre of the onion: not too low or you will lose that 'minaret' look.

When you are satisfied with the basic drawing, use a 2H pencil to refine and perfect it, rubbing out any excess graphite as you go. Include all the information you can see at this stage, so that when you begin to work up the drawing, you will not need to question its accuracy or rub out any veining, disturbing the form that the veins describe.

Botanical illustration

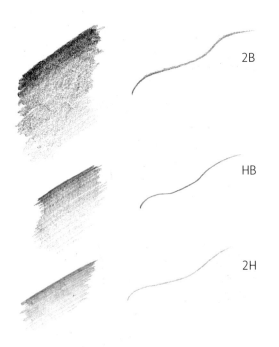

Figure 67.

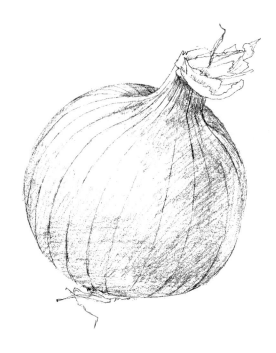

Figure 68.

Now consider your pencils. Test their properties on a scrap of paper, both at a soft shading level and as a sharp defining line. You should find that the soft 2B pencil is perfect for laying a foundation 'wash', having a much greater tonal range. The HB pencil will be used to create delicate form, and the sharp 2H pencil will provide detail and definition (Figure 67).

Begin by working over the whole onion with a 2B pencil, laying a delicate shade smoothly everywhere, except for the areas of shine. Blend the pencil marks carefully so that you do not create any lines or texture (Figure 68).

You can use an eraser to remove excess graphite if needed, but it is better to work slowly and carefully, considering where to build up form, so that no errors occur. You can use a blender or a clean fingertip to blend the surface, but again, a delicate approach gives a better result. Squint at the onion to help you identify the areas of light and dark, or use a table-tennis ball to help you see the shadows. Now build up the graphite in the darker areas to create form, not forgetting the reflected light, so that the darkest areas are in a rounded crescent shape or 'J' at roughly three-quarters of the way round,

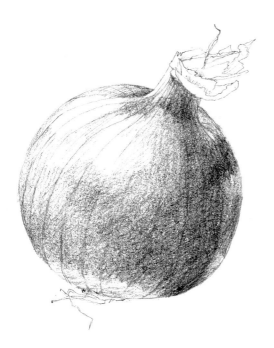

Figure 69.

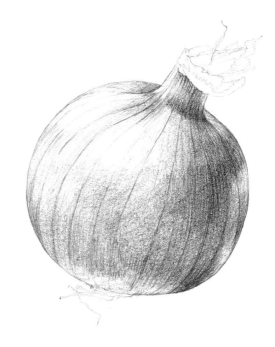

Figure 70.

away from the light source. You will find that the highlights form complementary shapes opposite the shadows, just as with the apple (Lesson 3) and the mushrooms (Lesson 4). By allowing light to move around the onion, both to the side and at the base, you will be able to greatly increase the form. Once you have identified the areas of shadow, you can turn the paper, laying graphite from the other direction (almost cross-hatching), to blend over the surface. At this stage, you are just laying smooth tone, regardless of the surface detail. The more shadows you put in, the brighter your highlights will be, and you

may need to tone them down or reduce their size. Continue building the form until you are happy that you have created a good three-dimensional shape, ignoring colour variations.

Use an HB pencil to polish and refine the surface. Turn the paper so your hand is comfortable working across the surface, and follow the direction of the veins. Redefine the veins, making sure that you continue the form by darkening them through the shadowed areas, and lifting off or leaving out the veins through the shine. Crisp and define the edges, without creating an outline.

Botanical illustration

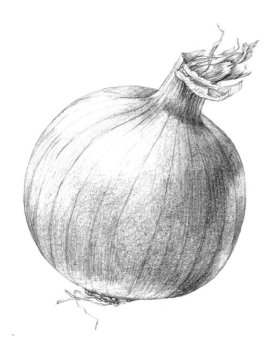 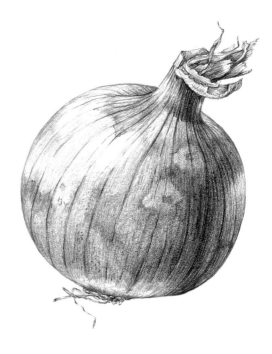

Figure 71.

Figure 72.

Now turn your attention to the ends of the onion. Use a sharp 2H pencil to increase definition, and to draw in the roots and stalk end, keeping the lines hard to reflect the dry texture of the material. Once that is done, go back to the HB pencil to increase the form in these small areas.

This time, look at the onion and consider its colour and any patterns or breaks in the skin. Use the HB pencil to add these, making sure that they are applied in a way that is consistent with the form.

The final job is to add more detail to the veining, and to make sure that the edges are cleanly defined. Gently build a small amount of form into the veins, both vertically – as they pass through light and dark – and horizontally across the onion.

When you are satisfied with your drawing, clean the surrounding paper with a rubber and use some fixative (hairspray will do) to stop it smudging. Hold the can about 25 cm from the drawing, and lightly spray over the surface. This holds the drawing in place, and will stop it being rubbed away, or transferring graphite elsewhere.

Use this technique whenever you are unsure where to paint to create form. Add shade to your working drawing so that you gain understanding of which parts are lighter and which are darker. For some subjects, such as roses, this is a great aid when painting the petals and maintaining the form of the flower as a whole. In a plant that will not survive the painting time, it is essential.

Critical assessment

* The biggest mistake when drawing an onion is inaccuracy at the start. The tendency is to measure the height of the onion as a whole, and then add the stalk on top of this, making it too tall. When measuring the onion, take care to get the proportions correct. Remember the drawing lesson, and rotate the scrap of paper around your most accurate measurement.

* If the onion lacks form, increase the 'J' shape away from the light. It may be necessary to lift out some of the graphite to increase the shine, by rubbing out through the highlight. Check that the veining correctly describes the shape travelling over the surface of the onion, beginning at the stalk and moving down to the roots. If the veins have become straight or are too evenly drawn, they will affect the form. Turn the drawing upside down to see it afresh.

* If your illustration is too dark, you may have used a soft pencil a little too freely. On the other hand, the only way to show light is by darkening other areas, and if the whole thing is too pale, add more graphite to the shadows.

* If the pencil lines are too obvious, use an HB pencil to blend and polish the surface, moving from light to dark. Then restore the detail with a 2H pencil.

* If the surface appears uneven, consider blaming the paper: its surface may be too coarse. If your pencils have little to distinguish them, blame them, and try a different brand.

LESSON 6:

Pen and ink

This lesson will throw stark emphasis onto the lines of the drawing. Any drawing that you do for a botanical illustration must achieve 'perfect lines' before you can continue.

By inking in a pencil drawing you will enhance the quality of these lines and clearly show the habit, structure and detail of your work, including any deficiencies. A pen and ink drawing is an essential part of botanical illustration, and is what most botanists still use to aid a written identification of a plant, along with enlargements, dissections, and microscopic detail.

For this lesson you will need two fibre-tipped pens: a 0.5 mm one for thicker, heavier lines, and a 0.1 mm one for fine detail. These pens are designed to produce a constant thickness of line, which can look clinical and lifeless. By using two different thicknesses of line, you can begin to replicate the quality of line that would be produced by a dip pen, which is italicised, producing a line that varies in thickness and gives a softer, more fluid effect. You could use a dip pen or even a fountain pen, as long as

the line is fine enough, but it is more difficult to control a dip pen, which will need to be recharged frequently, and just as frequently will drip and leave blots. In the past, I have used Rotring or technical drawing pens, but found they are constantly failing or becoming blocked, and they are very expensive. A cheaper alternative is to buy fine fibre-tipped pens, which come in a range of nib sizes. Whichever pens you use, test them on a scrap of paper and get to know the line they produce. When you ink over your drawing, take care not to smudge the lines with your hand, and when you have finished, make some lines on a scrap of paper. When you can safely rub over these lines without smearing, you know that it is safe to erase the pencil lines from your finished drawing – it hurts a lot to smudge a beautiful pen and ink study that you have spent hours working on.

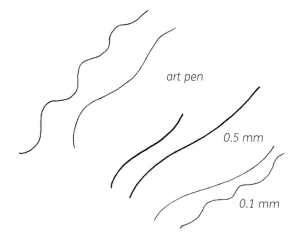

art pen

0.5 mm

0.1 mm

Select your subject, bearing in mind that the purpose of this lesson is to study line and structure, with the aim of creating a 'perfect line'. Your chosen subject could be a plant that is fine and linear, too fiddly to achieve a good result in watercolour. This work can be done on cartridge paper, but a better surface to work on would be a very hard white paper such as Fabriano 4 or 5, or Bristol board. Textured cold-pressed watercolour paper is not suitable, as the pen will catch on the surface, making it impossible to produce a fine line.

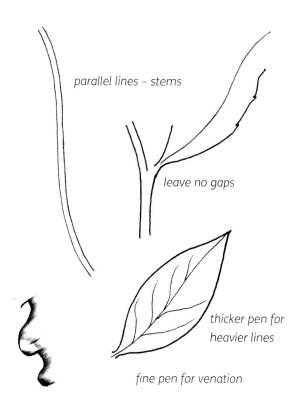

parallel lines – stems

leave no gaps

thicker pen for heavier lines

fine pen for venation

Figure 73. Practice lines.

Figure 74. Michaelmas daisy.

Botanical illustration

Figure 75. Pen and ink sketches.

Figure 76.

Place the plant in water, thinking about how it was growing when you picked it, so that you are also describing its habit. Twist and turn it to find the best angle to work from, with manageable foreshortening, and flowers and leaves presenting their best and varied features. Now consider the composition and the elements you may wish to include.

These might be extra flowers, enlargements, dissections or explosions. A series of small thumbnail sketches can help with planning, and can be adapted as the work progresses (Figure 75).

Using an HB pencil, begin by making a series of measurements to record the basic shape.

Figure 77.

Roughly draw in the plant to record its overall shape and position on the paper (Figure 76).

Carefully draw in more detail, cross-referencing each part, and checking again and again as you did in the drawing lesson. In a complicated plant such as this, it is important not to draw one flower at a time, but to make sure the positions of all the flowers relate correctly to each other, and to the stem and foliage. When you are happy with the preliminary drawing, work it up, rubbing out a little at a time and adding more and more detail. Use a 2H pencil to refine the drawing, until you arrive at the 'perfect line'.

Botanical illustration

Next, move on to the enlargements or dissections. It is sometimes possible to simply pull your flower apart. Otherwise, it may be necessary to slice through a section with a scalpel, razor blade or sharp craft knife. Place the flower on a board covered in white paper to help you see clearly what you are doing. Tweezers will be useful to separate very small flower parts, and a magnifying glass is essential to see the detail. This extra detail will help you to achieve a greater understanding of your subject, and thus inform your ability to make an accurate drawing. Try to structure the composition around the main study in a considered way, balancing drawings on a vertical axis, or flowing so that the dissections are linked, or at a greater enlargement. Try to include an enlargement of a petal, the stamens, and the stigma. Cross-sections are informative, and will help you to decide on which parts to include. To make the enlargements, take your measurements carefully and multiply them until you get to the required size. For this you can use either a piece of paper or a pair of dividers.

Here, I have placed a flower full on and enlarged x2, on the same line as a section through the flower at the same enlargement. One of the tiny flowers (disc floret) from the centre, showing the stigma, is balanced by a petal (ray floret) with a stamen attached, enlarged x4. Feel free to illustrate whatever you find in your flower. The bigger the flower, the easier the dissections will be. A very small flower may be impossible to dissect without a low-power microscope. Draw these using an HB pencil first, and refine the line using a 2H.

Before you begin, make sure you have not left too much graphite on your drawing, as this could interfere with the ink. By now the drawing should be perfect, and so accurate that you no longer need to look at the plant. It is essential to concentrate on producing a perfect line, rather than any redrawing. On a scrap of paper, practise the lines that you will need according to the size of the subject matter. It is useful to try out different areas of the drawing: if you have long straight lines to do, practise these, turning the paper so that your hand can comfortably make arcs and parallel lines. Be confident that you can make invisible joins, as it is not possible to make one very long line. The drawing should be fluid, so leave no gaps, as these will become very obvious when inked in. Select a pen that will both suit and complement the drawing. A very fine line for a large leaf will look too thin and not reflect the nature and weight of the plant. A line that is too thick will obscure the information you are trying to portray. Take your time, breathe slowly, and start at the top, so that you are not working over wet ink. Keep turning the paper so that your hand is comfortably pulling the pen over the pencil lines.

Figure 78.

I have used a 0.1 mm pen for the flowers and delicate stems at the top of my plant. Towards the bottom, where the stem is thicker, I have used a 0.5 mm pen to show the extra weight of the structure.

For the enlarged flower, I started in the centre using a 0.1 mm pen, as the detail is very compact, and used a 0.5 mm pen to draw the outer petals.

For the dissected flower, I used a 0.5 mm pen for the outline, and a 0.1 mm pen to draw the petals and disc florets. The enlarged disc floret was outlined with the 0.5 mm pen, and the top of the floret and stamen were drawn in 0.1 mm pen. The ray floret was outlined in 0.5 mm, and the finer lines of the anther were drawn in 0.1 mm. Remember to allow time for the ink to dry before rubbing out the pencil lines.

Botanical illustration

Once you have removed the pencil, sit back and check over your work, looking at it first from an aesthetic point of view, and then with a critical eye to see the lines, the shapes that they make, any gaps, spaces, heavy joins or mistakes. Use your finest pen to correct minor mistakes, fill gaps, and close lines. If you have made a more major error, use a sharp razor blade or craft knife to carefully scratch away the ink. Hold the blade flat to the paper and scrape away the error. This will damage the surface of the paper (here the quality of your paper will tell). Burnish the surface by covering it with a clean piece of paper, and rub with the back of your fingernail. Use the finest pen to correct the mistake.

I prefer to use line only, as I feel that it gives the best clarity and displays information most clearly (this exercise is all about line). However, if you wish to add shading, experiment with stipple or cross-hatching, but take care not to obscure the line.

fine lines

stipple

cross hatch

dots
dashes
+ broken lines

Figure 79. More practice lines.

Critical assessment

- The biggest problems relate to a weak drawing. Practise to perfect your accuracy.

- The composition here is secondary to the drawing. However, as always, it can turn a mediocre study into an exciting pen and ink illustration. If the composition has let you down, look at the work of others for inspiration.

- If the overall effect is too heavy, use a thinner pen. If the image is too spindly, use a thicker pen. Selecting the correct pen for the line you are drawing can make the difference between a pleasing image and one that is unclear or muddled.

- If your lines are sketchy, wobbly or ill formed, this will become apparent once they are inked in. Remember that this lesson is to help you work towards a perfect line. Practise lines, turning the paper so that your hand can hold the pen comfortably, flowing across the paper.

- If you have enjoyed producing a pen and ink drawing, have fun experimenting. It is not necessary to add dissections or enlargements. Any of your working drawings can be inked in to become pen and ink studies. Many students prefer to ink in all their drawings to aid clarity before tracing. Pen and ink is satisfying because you can get an instant and professional finish.

LESSON 7:

A flower

Select a flower. Choose a fresh specimen that will last the time it will take you to illustrate it. Begin with something simple, so not a multi-petalled flower, or white, or huge.

Place it carefully so that it is displayed at its best, and so that you can see all that you need to describe it at its most typical. Remember to consider its habit or how it was growing. Make sure it will survive by placing it in water.

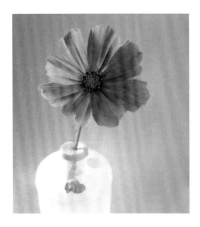

Figure 80. Cosmos daisy.

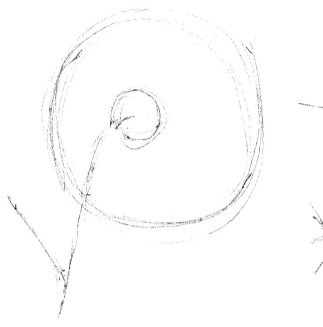

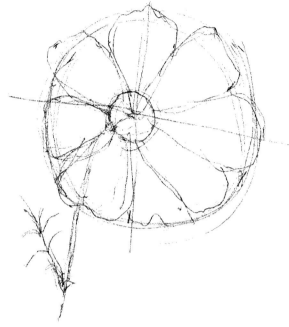

Figure 81.

Use an HB pencil and a scrap of paper to make
measurements, as in the previous lessons.
Measure the outer limits of the flower, and
record them in your sketchbook. Ensure that
the basic shape and structure are accurately
recorded, along with angles and relationships,
before drawing in more detailed information.

Figure 82.

Remember to include lines that you cannot
see, but that you know are important to
the structure, such as the stem as it passes
through the flower, and the direction and curve
of the petals.

Botanical illustration

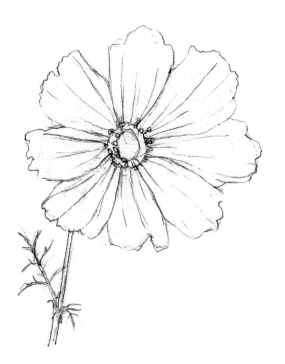

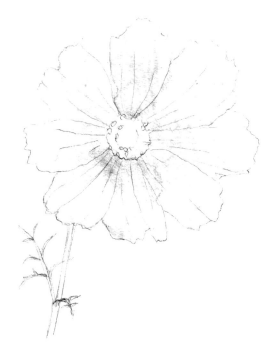

Figure 83.

Figure 84.

Work up the drawing, checking the measurements and adding more and more detail. When you are satisfied with the drawing, use a hard, sharp 2H pencil to define and perfect the line, rubbing out the HB lines as you go until you achieve the perfect line, which can then be transferred to your watercolour paper. Make sure to remove the excess graphite, so that the pencil drawing will be covered by the paint.

Mix enough of each of the colours you will need. Compare the colours, at full strength, to the flower, and then bring a small amount forward and dilute it to make a manageable wash. Use a large brush (size 6) to lay a dilute wash over the petals. Here, I have used neat Opera Rose, without any mixing because my flower is a bright pink. I have put the paint in my palette and diluted it, so that I can access the exact dilution without having to remix it. Lay a flat wash, without separating the petals, at this point. It is rather like painting by numbers, to identify the different areas of

Figure 85.

Figure 86.

colour. Allow each adjacent colour to dry, to avoid bleeding from one to another, but do paint all the different colours of the flower, as they have a great impact on each other.

Apply a second, slightly stronger wash, if needed, until you have achieved the highlights or the lightest of the base colours of the flower.

Now strengthen the colour again, and apply a wash around the centre of the flower. This will give depth to the centre. If you can see a ring of light about two-thirds of the way

along the petals, add more colour beyond this point, giving a curved effect to each petal. This will begin to give the flower a sense of form. Usually, the lower petal will be in the shadow of the upper petal, but this will depend on the light hitting the flower. Separate the petals by painting along the pencil line between them, leaving a firm edge against the upper petal, and blending the wash away into the lower one, and casting it into shadow. This firm line will cover your pencil, and the colour on the softer side is then blended in adding colour and form, and restoring the drawing. Remember

Botanical illustration

 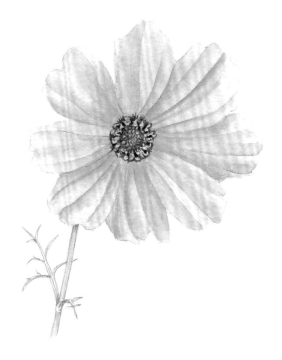

Figure 87.

Figure 88.

that each wash is a practice for the next one, so if it works, you will strengthen it, and if it doesn't, you will correct it.

Continue working around the flower, observing it carefully and prioritising the form by separating the petals to retain the drawing. At the same time, build up the other colours to help with the colour balance.

Now you can begin to add detail and form to the individual petals. Stay within the context of the form you have created. Use a smaller (size 0) brush to apply paint to the petals, blending to avoid harsh lines. Make the paint stronger, since the smaller the area you are painting, the stronger the wash can be.

Here I have built up the colour in the centre of the flower (Figure 88), by mixing a touch of Cadmium Red and Payne's Grey into the original colour to draw in the detail. I then used a mixture of Alizarin Crimson, Ultramarine Blue

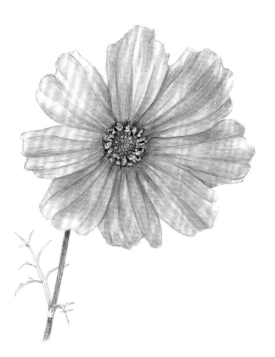

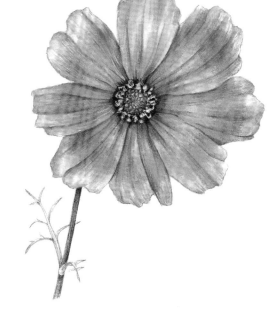

Figure 89.

Figure 90.

and Viridian to make a deep 'Botanical Black' to define the tiny flowers within it. This must be done with a dry brush, and the paint must be strong enough to define the detail without changing the colour.

Keep checking the colour, sitting back and comparing it to the original. I have added a small amount of Cobalt Blue to the Opera Rose, to tone down the colour and give more weight to the shadows, which are often cooler than the rest. Always refer to the form of the petals, so that you continue to lift off the colour

through the lighter areas and increase it in the shadows, and in turn, relate the petals to the form of the whole flower.

Make sure that you continue to enhance the form you have created, and be prepared to add colour or glazes of colour, or correct the structure. Here, I have added a pink glaze around the ellipse of the petals to make them curve more and explain the foreshortened petals on one side. Take care not to disturb the underlying detail. Check the centre, stem and foliage. I have applied a dilute glaze of Alizarin

Botanical illustration

Crimson over the green stem, to give a bronzed
appearance, in the same way that the colour
of the apple was altered in Lesson 3. Finish the
illustration by adding detail and definition in
dry brush: use your finest brush to almost draw
on extra detail, with the paint just a tiny bit
stronger than the colour you were using last.

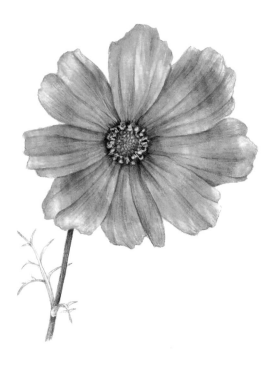

Critical assessment

• If the drawing was weak, no amount of technical detail will correct it. Always make an accurately observed drawing before you start to paint.

• If the flower no longer looks like the illustration, blame the flower for changing. During the course of your work the flower will have turned, or aged, or died, and the level of observation that you are using will take note of tiny differences. You could use another flower as a secondary reference, or adapt your illustration as you go along, or make more detailed notes on your working drawing.

• If the colour is incorrect now that you have brought it up to full strength, use delicate colour-correcting glazes. Next time, sit back and compare the colour as you work, as it is quite easy to get lost in detail and lose the whole impact.

• If the form is unresolved, add washes to enhance the ring of light, adding form and shadows to give curvature to the petals. Remember to increase the strength of each wash that you do: the smaller the area, the stronger the paint. Otherwise you will be forever adding more washes without enhancing the form.

• If the illustration lacks definition, use a dry brush to enhance the detail and definition in line with the form, by carefully crisping the edges and separating the petals.

LESSON 8:

Foliage

This lesson is aimed at helping you to illustrate foliage. Of all the complaints I hear, the most common one is dissatisfaction with leaves. Leaves are an important part of botanical illustration, not only for the purpose of plant identification, but also as a foil for flowers, buds and seeds, balancing and enhancing colours. Never neglect the leaves of the plant you are illustrating. Well observed and well recorded leaves can make all the difference to your completed illustration.

Here, I placed a small piece of bay in a flower tube, with a thought to how it was growing, so that the leaves are overlapping, but I can still see the structure of the stem.

Begin by plotting out and recording the limits of the plant in your sketchbook, using an HB pencil as in earlier lessons. Show the dimensions and directions of the leaves. Work up the drawing, refining and correcting your observations. Remember to accurately record any foreshortening, and to cross-reference the position of one leaf to the next, looking at spaces and angles. Refine the detail with a 2H pencil, adding leaf margins and veins and

Figure 91. Bay foliage.

Figure 92.

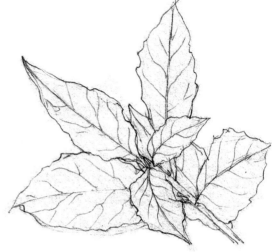

Figure 93.

recording the attachment of leaves to stem. When the drawing is fully realised, transfer it to watercolour paper, making sure that only a light pencil line is on the watercolour paper.

Think of the way you painted the single leaf in Lesson 2. This time you are going to use the skills you acquired there, and add to them, as you must consider the impact each leaf has on its neighbour. Start by mixing the base colour – the colour of the midrib – and lay a delicate wash over all the leaves. Here I have used Linden Green, Cadmium Yellow and Cobalt Blue. You should be able to lay this wash over all of the leaves without stopping at the edge of each leaf, as the pencil line should still be visible.

Figure 94.

Botanical illustration

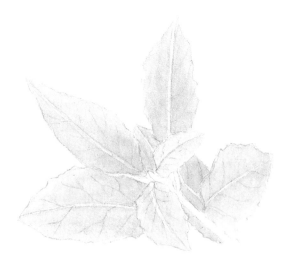

Figure 95.

Figure 96.

Now make the wash stronger and use it to add form to the leaves. Prioritise the form so that the more important shadows are shown first, to separate the leaves. The leaf behind or underneath is usually darkest. By painting onto each leaf the shadow of the leaf in front of it, you are defining the drawing as well as creating form and recording the light (Figure 95). Take care to blend each shadow away so that the colour remains at the original strength away from the edge. This way you can continue ad infinitum, making each leaf darker, but only at that edge. Don't worry about anything else at this stage. Work on only one observation at a time, so that the separation of the leaves and the blending away of the colour

do not affect the next observation, which you can record later.

Next, mix the colour for the main part of the leaf, comparing it at full strength to the leaf itself. Here (Figure 96), I have taken some of the base colour and added more Cadmium Yellow and Cobalt Blue, with a little Ultramarine to make a stronger and heavier colour. Dilute this well, and lay flat washes along the midrib of each leaf and out across the blade. Leave a small gap and wash over the other half of the leaf, leaving the midrib in the base colour. The darkest leaf, at the back, I have painted a little darker to differentiate it from the ones at the front.

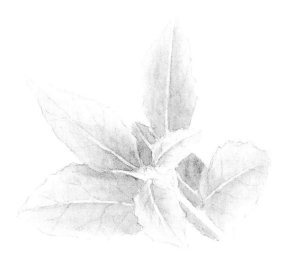

Figure 97.

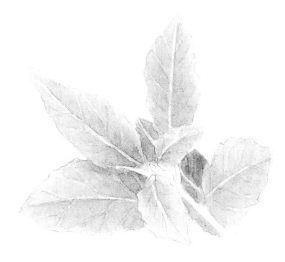

Figure 98.

Again, make the paint a little stronger and redefine the form that you identified in the base colour. Take care not to lose the original drawing, by maintaining the contrast of one leaf against its neighbour. If you get lost, refer back to your working drawing.

Now work along each of the minor veins as you did for the midrib, using the pencil line to create one side of the vein. At this stage, the paint is going on flat to make bands of colour, leaving out narrow, negative lines for the veins.

Look closely at the plant for reference. One half of the leaf should be darker than the other. Build up the form on each leaf by laying a

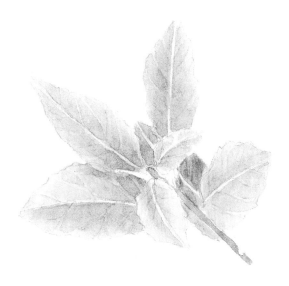

Figure 99.

Botanical illustration

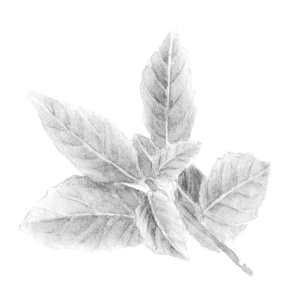

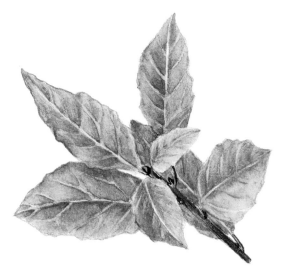

Figure 100.

Figure 101.

delicate glaze down one side of the midrib and blending it away. Don't worry about anything else at this stage. This is a good time to add colour to the stem, linking the leaves together.

Add form to the minor veins by painting along the shadow of each one and blending the colour away. Use a smaller, size 0 brush.

By only concentrating on one aspect of the leaf at a time, you now have the basic form, shape and colour of the plant. Continue building up the colour, making each wash a stronger version of the one before. Keep checking the colours: the younger leaves at the top of the plant are often a bright, fresh colour, so for these you should change back to the very first colour you used. Work on the margins of the leaves: some will be defined by the leaf next to them, others will need to be defined with a dry brush, carefully depicting the margin. My bay leaves have undulating edges, which are best shown by painting little triangles along the outer edge and blending them in.

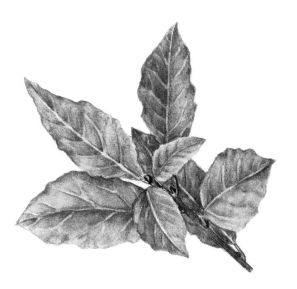

Figure 102.

Figure 103.

Leaves at the back should not be neglected. Make sure that they contrast with the leaves around them – usually they are darker. Paint partially obscured leaves consistently, so that when they pass behind an obstruction, they reappear at the same depth of colour. If the veins become too prominent as the colour increases, tone them down with a dilute glaze of the base colour.

Finish the illustration by detailing and defining with a dry brush, crisping the detail and edges without outlining or leaving hard lines.

Botanical illustration

Figure 104.

It is important that you continue to look closely, ask questions of your subject, and record in detail all that you see with the naked eye. Sometimes it is useful to use a magnifying glass to look at small detail, but it is not always possible or even desirable to record all that you see, as in doing so you can obscure things of greater import or impact.

Critical assessment

- If your drawing has become lost within the painting, refer back to your working drawing. The light may have changed during the course of your work. If you have been changing the lighting in your work in line with the light changes throughout the day, the change in contrasts will undermine the painting. Stay with your original observations so that contrasts are maximised. If necessary, wait until the light conditions are the same as when you began work, i.e. the next day.

- If the midrib of the leaves has been lost, use a damp brush to lift them out, blotting with blotting paper if needed. Make sure that the midribs still run true, through the centre of the leaf, with areas of light and dark, and that the minor veins curve delicately out.

- If the leaves have become too textured, or brush strokes show, use a damp brush to polish the surface, gently polishing over the surface without lifting off the paint.

- Don't be afraid to overlay corrective glazes of watercolour to adjust the colour, tone or form. This can also be used to link veins, or soften over-worked areas. This can greatly enhance the appearance of your work.

- If you find that you have lost contrast and form, take care that you have not extended your washes too far. Apply paint to the area that needs it, and blend it carefully with a damp – not wet – brush, controlling how far the colour travels. If necessary, push the paint back into the stronger colour, rather than pulling it out and losing contrast.

- If the leaves appear fuzzy and ill defined, look at your dry brush technique. The paint should be the same colour as you have been using, but must be quite concentrated: dry enough to define, but wet enough to flow. If it is too dilute it will have no impact; if it is too strong, it will act as an outline, killing the form. The final work in dry brush is the icing on the cake, and will add clarity and brilliance to your illustration.

- Above all, keep looking at the plant.

LESSON 9:

Leaves and berries

This lesson is about illustrating berries (or a lot of little apples) and leaves, contrasting their colours and form. Berries are lovely to paint, with bright colours and shine. The techniques learnt here can be used to illustrate any round fruit, from seasonal nuts and berries to crab apples and holly.

I have placed a small piece of hawthorn in a flower tube with water in it, on white paper, to increase the contrasts. Take care to show its habit, and the best view of the berries and leaves.

Figure 105. Hawthorn.

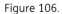

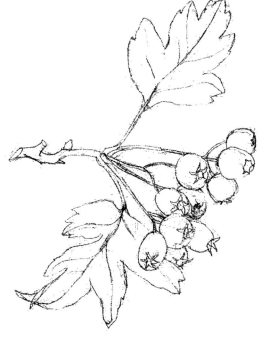

Figure 106.

Figure 107.

In your sketchbook, start by measuring the outer limits, positioning it on the paper, and recording the angles and spaces with an HB pencil. Observe where leaves come from, and how they are attached. Make the stalks pass through the berries, giving you the exact point to draw the end (the dead flower).

Work up the drawing to full detail as usual, perfecting and refining the line with a 2H pencil, and transfer it to your watercolour paper.

Mix all of the colours you will be using, and lay dilute washes on the appropriate areas of the illustration. This can be a little like painting by numbers, but it is the basis of the whole study, and serves to ensure that you do not paint any spaces. By working across the illustration as a whole, each colour will be dry before you return to it, and the colours will be balanced against each other.

Botanical illustration

In Figure 108, I have mixed Lemon Yellow with Cobalt Blue for the leaves. I have laid this colour on the berry stalks, so that they will appear bronzed when I paint them red later, as with the apple in Lesson 3. I have mixed Cadmium Red with Alizarin Crimson for the berries, making a fresh, bright colour to lay underneath the deep red, because it is easier to control a lighter, brighter colour. If you dilute Alizarin Crimson it becomes pink, but you can avoid this, and keep the berries fresh, by underlaying a brighter red first. I have left a small area of shine on each berry, polishing around the edge, and making sure the 'shines' are consistent across all of them. For the woody twig, I have mixed Burnt Umber with Cobalt Blue to soften the colour.

Increase the colours by bringing more of your mixed colour into your dilution. In Figure 109 I have strengthened my green and washed either side of the midrib on each leaf, to leave the midrib as a negative. You need to paint each of the berries as if it was an apple; this means creating a darker side away from the light, and leaving a highlight on the light side. However, you cannot take each berry in isolation, but should consider how each one impacts on the one next to it. Therefore, it is best to start with the berries at the back. I have made these darker, which lifts the front berries and throws the back ones into shadow. Look closely: by allowing the light to travel

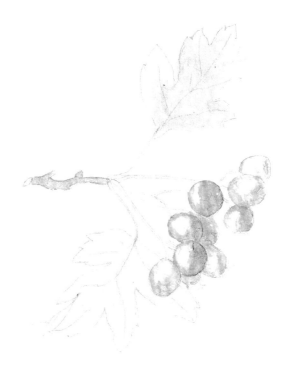

Figure 108.

around the berry, so that the darkest area is not at the edge, the berry behind can be painted even darker. If you painted the front berries in isolation, and took the paint to the edge, it would become impossible to make the back ones any darker. These first few washes are about defining the drawing and making a value judgement for each relationship. The drawing must be preserved before it is obscured by paint, and by recording shadow at the beginning, you establish the form straight away, and make sure that you do not need to make a heavy outline to show a firm edge.

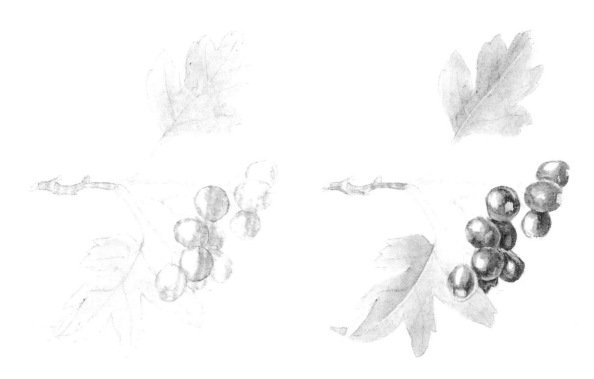

Figure 109.

Figure 110.

If the light changes or the plant dies, you will have a record of it lightly depicted. Continue on this theme, remembering that each wash is a practice for the next, stronger wash. Where the leaves touch the berries, take care not to allow colours to run into each other.

Continue strengthening the colours and enhancing the form, as I have in Figure 110. I have ignored the dark ends of the berries, as I do not want that colour to run into the red, and will leave the fine stalks of the leaves and berries till the end, when I will do them in

dry brush. Fine lines should not receive more than two or three applications of colour, as the more you go over them, the coarser they will become. Remember: the smaller the area, the stronger the wash. Each wash will be in a stronger colour, over a smaller area. Keep checking the colours and comparing them to your subject, to make sure that the colour and form are well observed.

Next, work in more and more detail, defining the minor veins and detailing the curved edges.

Botanical illustration

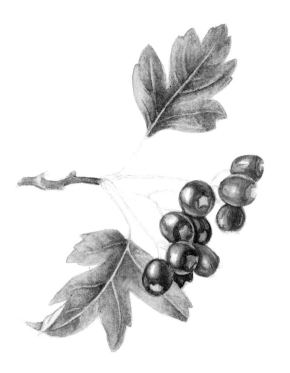

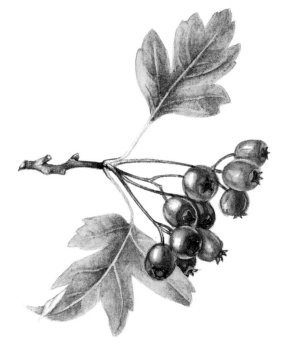

Figure 111.

Figure 112.

I have increased the weight and depth of my green by mixing in some Cadmium Yellow and Ultramarine. This stronger yellow means that I can add more blue to the mix and still keep the colour green. I have added some form to the twig by increasing the colour along its lower edge. The berries are becoming darker, but if the shine is too bright, I will close it down, reducing the size and contrast.

Here I have painted the stalks of the berries using the brown from the twig mixed with the red from the berries. For this fine detail I have used the paint very dry, but not too strong for the first time; strengthening the paint to add depth to the lower stalks, and adding form to them as they attach to the berries and the twig. As the centres of the berries were getting left behind, I mixed 'Botanical Black' (Ultramarine, Alizarin Crimson and Viridian) and carefully redrew the five-pointed structure, then increased the colour to define the form. I have added more Alizarin Crimson to my mixed red, to deepen the colour and enhance the form of the berries.

Critical assessment

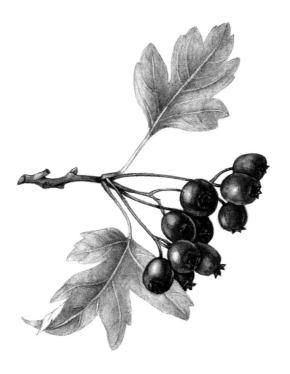

Figure 113.

For the final detail, I have used the same colours at an increased strength, and dry brush to enhance the detail and definition. The berries have been finished by adding a small amount of Ultramarine to the Alizarin Crimson, to achieve a metallic sheen.

- If your illustration lacks form, use delicate glazes of colour over areas of shadow. It is often necessary to revisit form and colour as the contrast is increased. Check the balance and form by turning the illustration upside down.

- If the berries lack shine, it may be that by increasing the depth of shadow, you can brighten the shine. If necessary, use a damp brush and then blotting paper to lift out the area of shine. Repair the colour when the paper has dried. Remember to paint one berry in relation to its neighbour, so that the one behind is in the shadow of the one in front.

- If the colours have become muddy, consider the paint you have used. Some colours behave badly when mixed together. Try a different colour combination to achieve a similar result. Change the water frequently, especially between reds and greens.

LESSON 10:

Botanical plate

This is the culmination of all you have learnt so far. It is an opportunity to really think about composition and the placement of your work on the paper. By cropping some parts of a plant, you can direct the focus on to other parts. If your plant is very tall or large, you can crop it at a suitable point, or select a section to concentrate on. Without cropping, some images would be huge, or very long, with too much space around them, or impossible to mount and frame.

Figure 114. *Phalaenopsis.*

Bear in mind the following points:

• Try to include different elements of the plant, to show buds, different views of the flowers, seeds and leaves.

• Do not crop through a flower.

• Crop leaves at reasonable junctions, not just nipping off a tip, and do try to include the whole of at least one leaf.

• Balance the flower spike with the base of the plant.

• Make a series of thumbnail sketches to try out different ideas.

• An illustration of this size and complexity should take about twenty hours to complete. Given that it is not possible to finish within one day, choose a plant that will last.

Your working drawing is your biggest asset here, as you can improve the composition by repositioning the separate elements as you transfer them. You will also be using the working drawing for colour and shading notes.

For this lesson I am taking the dimensions of a plate that would be used for *Curtis's Botanical Magazine*. You could set yourself any size, or use a frame that you already have. Leave a small margin around the edge of the work, and stop the painting at this line, so that when mounted, the illustration is deliberately inserted into the frame rather than crammed into it. As you draw, if the composition requires it, you can move the aperture around to alter the focal point. The size I have used is 12.5 cm x 20.5 cm, and I have marked out this area on my sketchbook paper.

Botanical illustration

Figure 115.

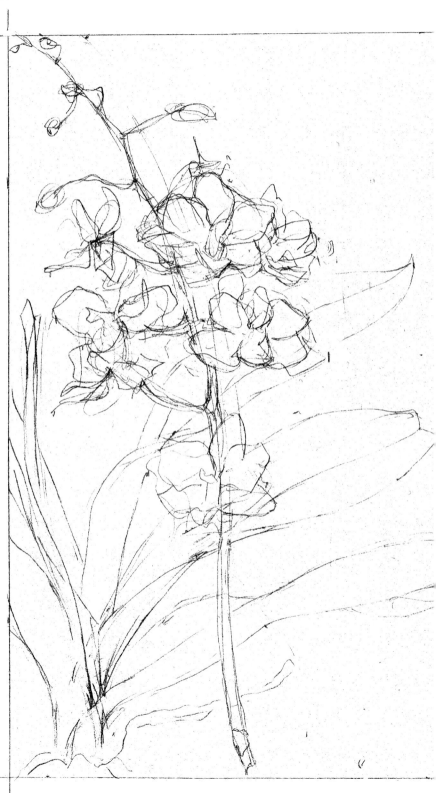

Use an HB pencil to record the plant's basic structure and measurements. Try to use every inch of space. By positioning my flower spike in the top left-hand corner, I can allow it to fall down the plate. It is balanced by the base of the plant, which I have positioned so that one whole leaf is shown, as well as the important junction of the flower stem. Here I have plotted out the basic composition, though this may change and evolve as I work. Continue refining the drawing as you did in the previous lessons, constantly observing and recording detail without losing the overall habit of the plant.

Figure 116.

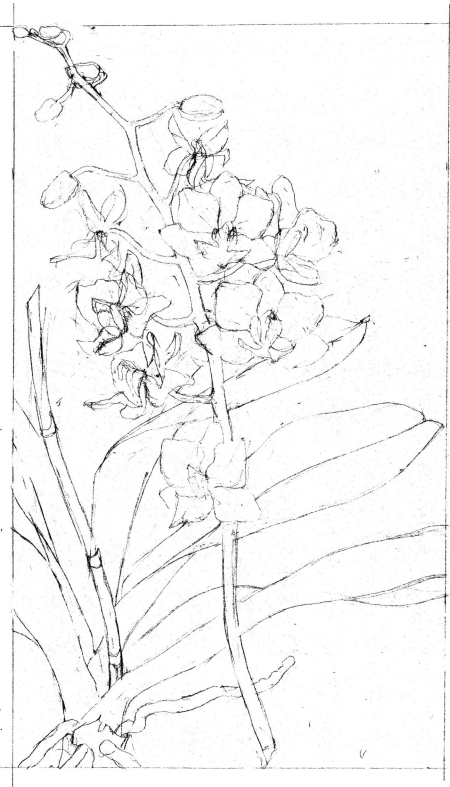

Remember to maintain a constant distance when measuring: by not moving closer to measure a flower at the back, you will ensure that the plant's three-dimensional depth is shown. Bear in mind the habit of the plant, the structure of the flowers and the shape of the leaves. If elements clash or obstruct each other, or meet at unfortunate spacing, carefully reposition them. Move your head or the plant slightly, so that the offending element is still correctly positioned, but more informatively placed. I have altered one of the buds, and the lowest flower, to enhance the composition.

Botanical illustration

Figure 117.

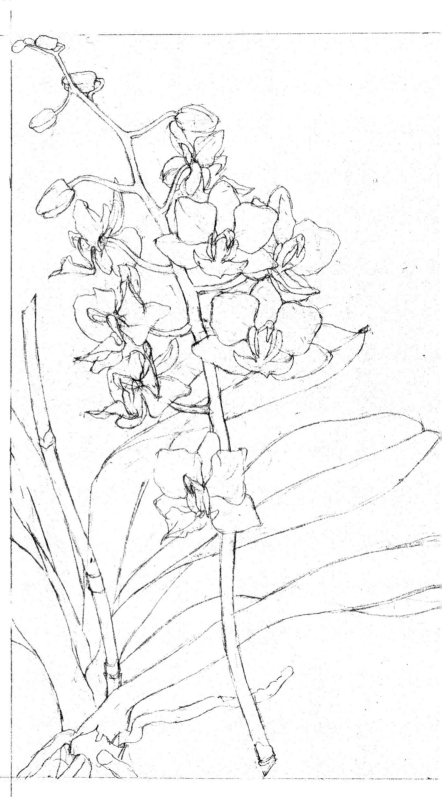

It may help to finish some of the leaves, if you draw them beyond the frame. I have cropped the bottom of my flower stem with a diagonal cut, repeated at the top of the lower section. This way I can make it clear that the two fit together.

Now return to your drawing, refining it with a 2H pencil until you have achieved a perfect line. Think of the amount of time that you will spend on painting this illustration, and allow plenty of time to get the drawing right.

Figure 118.

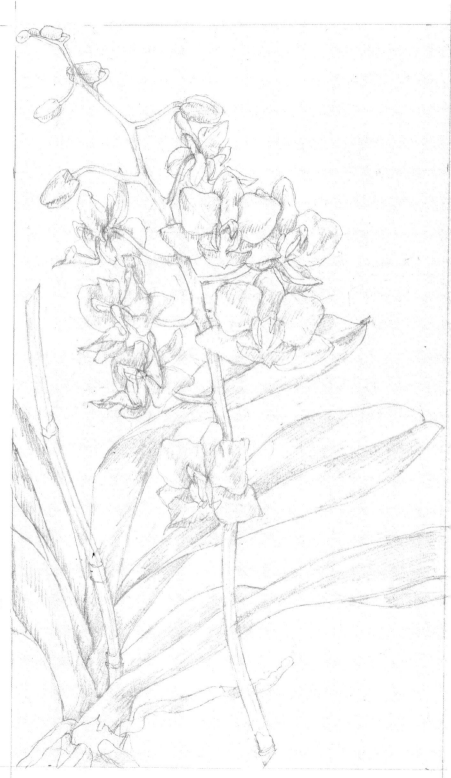

Transfer your drawing to watercolour paper, along with the outer lines beyond the aperture. (These will act as registration lines, without imposing on the illustration.) After you have finished transferring it, but before you begin to paint, use the drawing in your sketchbook to create a highly informative working drawing. Make carefully observed shading notes to identify light and dark, and prioritising form, to help you when painting. This does not need to be as detailed as for the pencil study in Lesson 5, but you should use the skills you learnt there to help you.

Botanical illustration

Take care not to obscure the actual drawing. I have used an HB pencil to describe the shadow, noting which area of each element is the darker, and more minor moulding where necessary.

Make colour mixes and record the areas where you will use them, noting the colours you have used. You will inevitably need to mix more colours as you work, and this will help when memory fails. All of this will also be invaluable if the plant deteriorates.

Using a size 6 brush, lay delicate washes of the correct colours onto all the areas of the plant. This is about painting by numbers, and is essentially to make sure you don't paint a space, or a flower green, or a leaf pink. These washes will also give you colour readings and balances, acting as a reminder of neighbouring colours. It can also be quite scary to apply a different colour later in the work, so get the scary parts out of the way early on. As some of the flowers are against the leaves, they will need to be painted differently, so by putting the two colours together, you will be reminded of this. This can also be used as an opportunity to consider the balance of the overall illustration. To emphasise the flowers, I plan to keep the leaves delicate and full of light, making use of the light hitting them.

Figure 119.

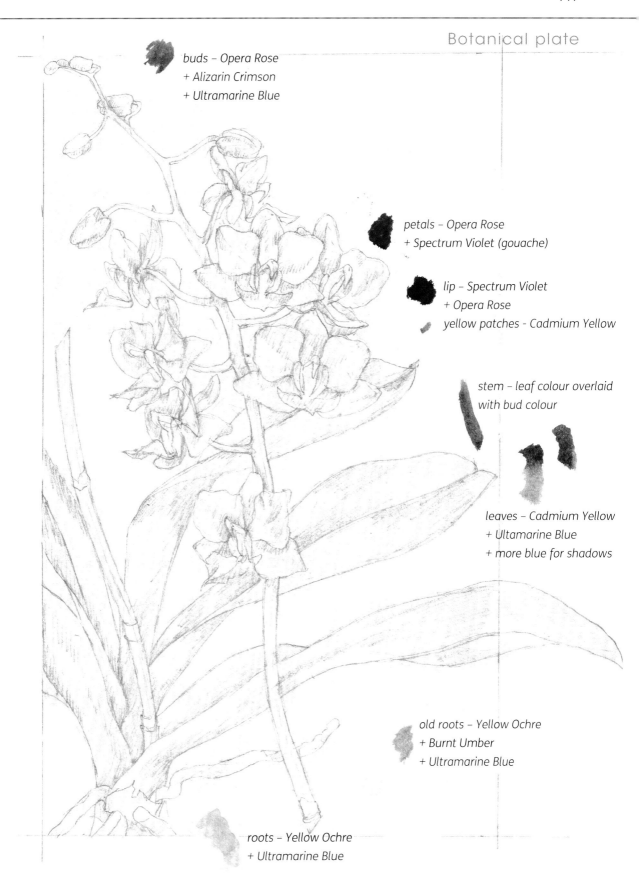

buds – Opera Rose
+ Alizarin Crimson
+ Ultramarine Blue

petals – Opera Rose
+ Spectrum Violet (gouache)

lip – Spectrum Violet
+ Opera Rose
yellow patches - Cadmium Yellow

stem – leaf colour overlaid
with bud colour

leaves – Cadmium Yellow
+ Ultamarine Blue
+ more blue for shadows

old roots – Yellow Ochre
+ Burnt Umber
+ Ultramarine Blue

roots – Yellow Ochre
+ Ultramarine Blue

Botanical illustration

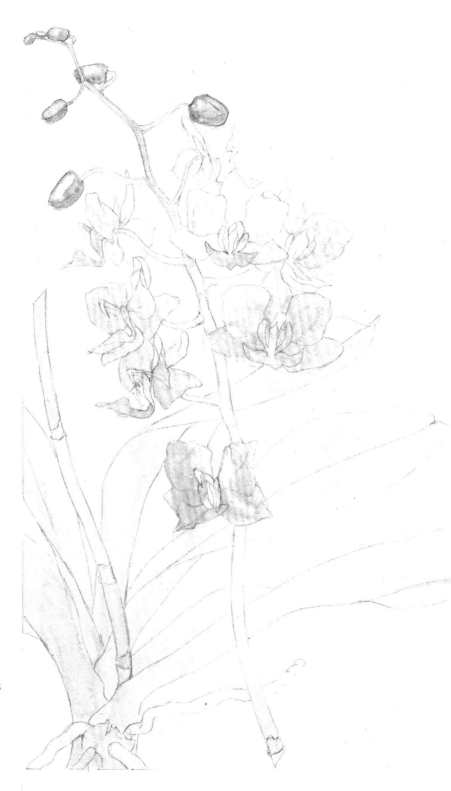

Figure 120.

Now consider the viability of your plant. The leaves should remain fairly static; the flowers may go over; but the buds will open to produce more flowers, and these will not be replaced. Therefore, concentrate on the buds and flowers first. As the area to be painted is small, use a size 0 brush. You can use the paint a little stronger, still taking care to record the light and dark. It is not necessary to finish them – I always allow a little extra 'finish' for the end, so that I can balance the composition. Then work on the rest of the flowers as

Botanical plate

Figure 121.

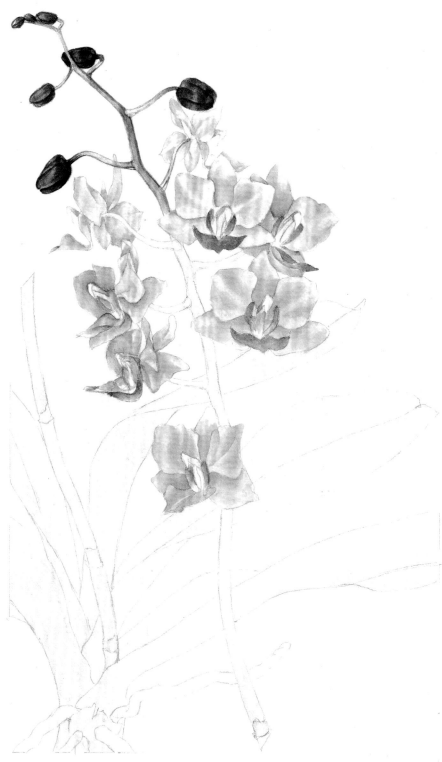

you have in previous lessons. First, prioritise the flower form, so that one flower, usually the one behind, is darker than the one in front. Then you can work on one flower at a time, creating form by working on one petal in relation to the one next to it. Only work on an area that you know needs to be darker, so that by painting along the edge of one petal you are separating it from its neighbour. Blending the paint away to nothing on the other side allows you to deal with the next area of form later.

Botanical illustration

Figure 122.

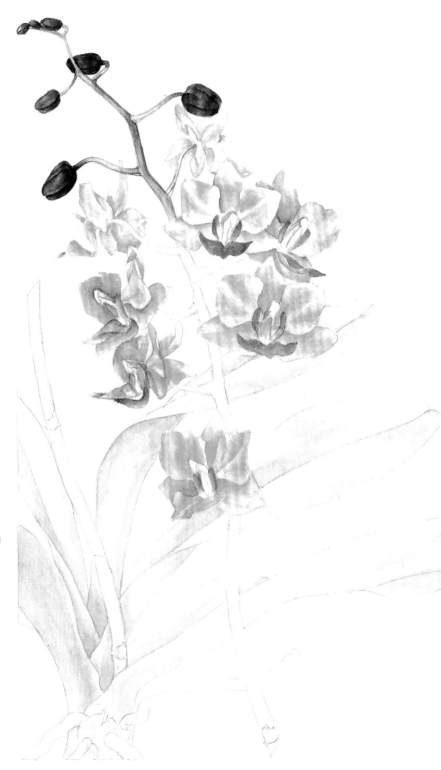

Remember that each wash you do is a practice for the next one. If you are happy with it, reinforce it. If not, alter the form to create the effect you are after. This more detailed work must be based on closely observed detail, and gives you a chance to correct any mistakes or discrepancies. Refer to your working drawing as well as observing the plant in detail.

Now with clean water, introduce some form into the foliage, again recording which is lighter and which is darker, using the edge of one leaf to describe and define its neighbour, before

Figure 123.

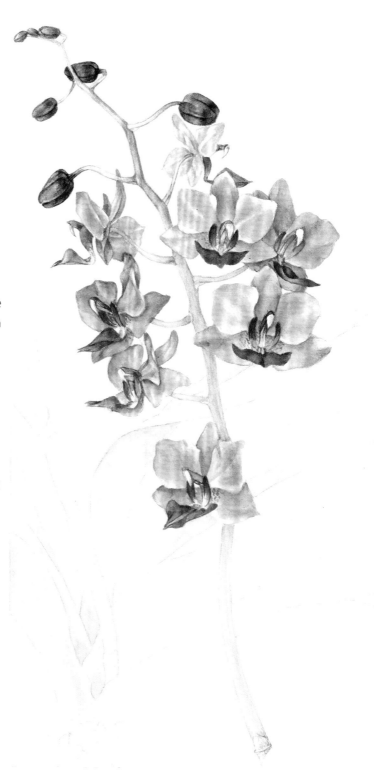

dealing with form within the leaf itself. Use a size 6 brush for larger areas, and use dilute paint so that you can control the leading edge. Take care to keep the outer, cropped margins of the illustration neat.

Return to the flowers, building up the colour of the individual petals with reference to the flower as a whole, while retaining the form identified in the flower spike as a whole. This sounds like a lot to do, but concentrate on applying paint to an area that you can clearly see needs it, and only where you can control the leading edge of wet paint.

Botanical illustration

Figure 124.

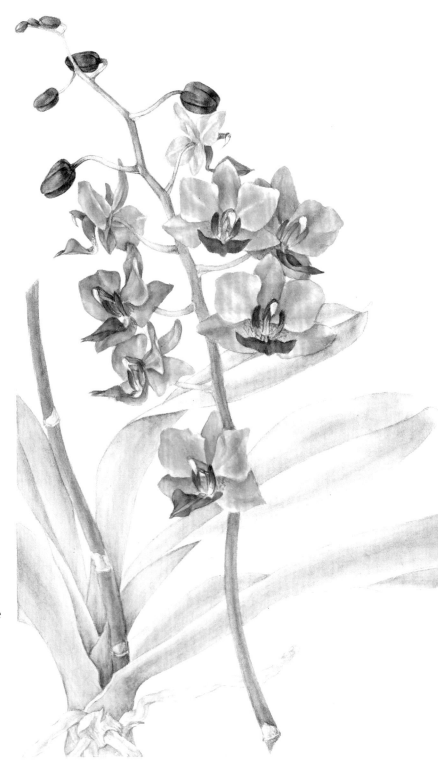

The paint will be getting progressively stronger, as the smaller the area, the stronger the paint can be. Make use of your working drawing, in which you have already identified which parts of the flower are light and which are dark.

The flowers and stem are well formed now, so return to the leaves and base of the plant, balancing your illustration and ensuring a good level of contrast between the flowers and the leaves. Change the water and replace the paper towel if necessary, and using a bigger brush and dilute paint, build up the form and

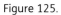

Figure 125.

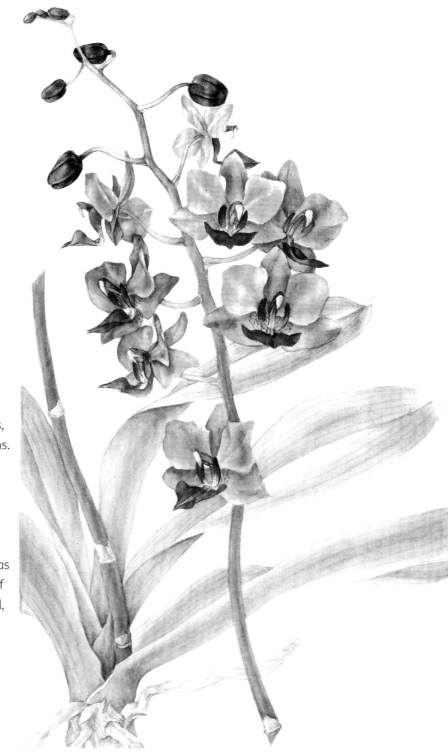

shine on the leaves. I have increased the amount of Ultramarine in the green, to enhance the shadows, which are cooler, and to complement the flower colour. Take care when working around the flowers, so that the contrast remains.

Where the stem passes in front of the leaves, the light on the stem is seen away from the edge, so that the leaf can be clearly defined, as it is darker. Once the form of the stem has been achieved, remember the apple in Lesson 3, and lay a dilute glaze to correct the colour. Form can then be added to the stem in this colour.

Botanical illustration

Figure 126.

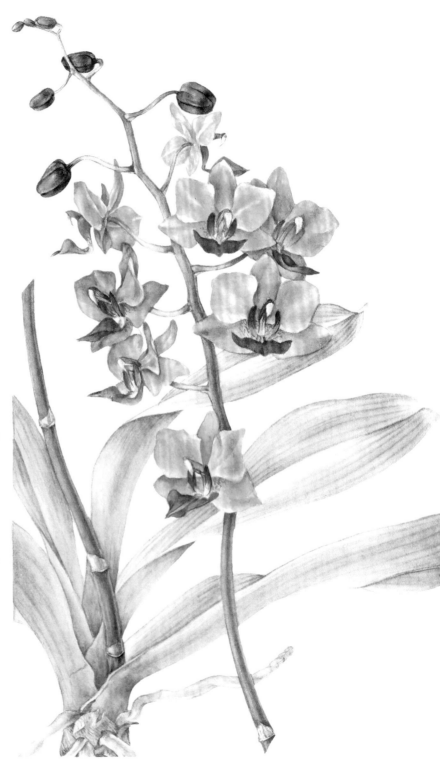

I am deliberately leaving the foliage pale, so that the emphasis is on the flowers. This is a design choice that can change as needed. Now finish the leaves by adding the veins and detailing the roots. With dilute paint on the large brush, carefully draw on the veins. Work along the outer edge, curving them to merge along the midrib. If you are not confident doing this, practise the movement by drawing the veins on your working drawing first. The veining on this orchid will remain subtle, but will add a little more colour and will increase the form of the illustration. Now add form to the veins: first across the blade so that any raised veins cast a shadow; and then along the length of the leaf, so that the veins

Figure 127.

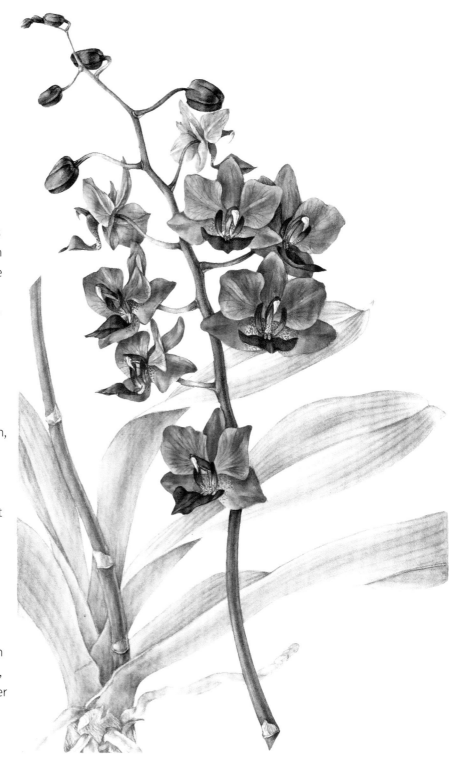

are darkened where the leaf passes into shadow. As you did for the single leaf in Lesson 2 and for the foliage in Lesson 8, add glazes of extra colour to increase the form as you work. If the veins are too prominent, polish them out a little to make sure that they are consistent with the form. Sit back from the illustration, to take stock of your work so far.

I have added a tiny amount of pink (the bud colour) to some of the edges of the leaves where the colour changes. I have used this colour to define the stem, leaving a shine where the light hits it. Use this to finish the stem the whole way up, and along each of the flower stalks.

Botanical illustration

Return to the flowers, building up the colour
and maintaining the form. Keep looking at the
plant, checking your earlier work and making
minor corrections as you go. If necessary,
enhance the colour with a delicate glaze, as
you did in the previous lessons. A transparent
glaze can correct the colour, add weight and
form, and link in a weak area.

Add detail and definition using dry brush,
blending the detail into the form so as not to
leave heavy outlines. Add subtle detail such as
veining on the petals, blending it in to follow
the form and shape already illustrated. Make
sure that the flowers are fully attached to the
stems by adding weight and contrast to the
stems, using them to increase the definition of
the petals.

Turn your illustration upside down and consider
its overall balance in terms of colour, weight
and detail. Then turn it the right way up and
check over the whole thing, using dry brush at
the same strength as the surrounding paint to
crisp and define, or add glazes of colour to add
weight and form.

Work around the flowers with extra care where
they meet the leaves, so that you do not
disturb the contrasts already recorded. Take
care not to over-work the illustration, while
making sure it is perfectly finished.

Figure 128.

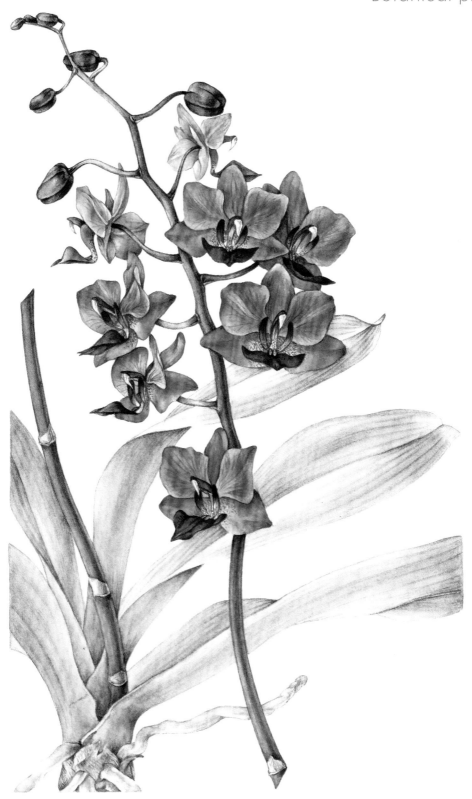

Critical assessment

- The biggest problem is knowing when an illustration is finished. If the image is pale and washed out, increase the colour with delicate glazes. If it lacks clarity and definition, use dry brush to crisp and enhance the level of finish. If it is heavy and over-worked, carefully lift out some of the paint in places, to add light and delicacy. Be careful not to leave heavy outlines.

- A poor working drawing will result in a poor illustration, or at least an illustration that you have struggled with. Make it easier for yourself by producing a highly detailed working drawing that answers as many questions as possible in terms of line, structure, form and colour. At this stage, you will find yourself becoming very fussy about minor changes in the plant. That is because your level of observation has increased to the point where 'similar' is not good enough.

- Often you can only see how the composition will turn out when you apply the first washes of colour. If you are not happy with the composition this time, try something different next time. By cutting and cropping your illustration, you can transform a mediocre study into an exciting and contemporary illustration.

- If individual flowers have died, turn the original plant so that you can use a similar flower for reference. If the plant has died or changed and your working drawing is insufficient, you will have to finish using a replacement plant. Try to find one as similar as possible, and use the parts of it you need, turning it around to match the original.

- Don't allow yourself to be distracted by finishing one flower at the expense of the plant as a whole, especially if that flower is not going well. Leave it to dry while you work up the surrounding area. By the time you return to it, any mistakes will be less obvious, and as the whole plant emerges, you will have a better idea of the corrections that need to be made. A painting of this size is more of a team effort in terms of its component parts, though that should not mean that you work at less than your best on an individual section.

- If you are overwhelmed and don't know what to do next, relax and work on a small part that you are more confident of. By painting a small section that you know how to do, you will increase your confidence, and decrease the amount left to do, so that the hard bit is less daunting.

Conclusion

Throughout these lessons, you have been concentrating hard on your chosen subject. Hopefully you have found this to be a little oasis of calm in your busy life, and can continue to do so. Having gained an understanding into the time it takes to produce a botanical illustration, you can now appreciate the amount of work involved. Unfortunately, the advent of digital photography, and computer manipulation of images, have undermined the art of the botanical illustrator, with few publishers willing to pay the price of commissioning artwork. A few are still able to value the skills of the illustrator, and continue to commission them especially for plant identification, where an illustration has far more to say than a photograph.

These new skills can change the way you look at the world, making you see colour differently, understand light and dark, and question structure and form all around you. All that you have learnt can be used for any drawing and painting that you do, but I hope you will continue to build on these skills and techniques and continue with botanical illustration. There is so much more to learn and to achieve.

Mounting and framing

Your finished artwork should be carefully stored and protected. Small pieces can be kept in hard-backed folders with clear plastic inserts. Larger work can be protected in a portfolio.

Illustrations gain 'finish' when they are mounted and framed, and while this can be expensive, it is so rewarding to see your work displayed, that it has to be recommended for some of the illustrations that you are most pleased with. A well-cut mount carefully placed around your illustration reduces the amount of white paper surrounding it, and moving the mount around can change the impact of the work. Sometimes, an offset mount can add interest by altering the focal point of the image. Cropped pieces should always have a narrow margin left between the illustration and the mount so that the work is not crammed into the mount. Have a mount cut to the correct size: artwork will look lost in a huge mount, and squashed in a tiny one. An ivory-coloured mount is favoured by most botanical illustrators, with a double mount if possible. The inner mount can be of a complementary colour, picking out the greens you have used, or sometimes a daring pink or purple can be used to match the flower within.

Choose a simple frame that will complement and not overwhelm your illustration. A pale beechwood frame works well. Avoid dark oak or ornate gilt or silver frames, which will overshadow an illustration. If you have suitable frames that you wish to use, it can be cost effective to create artwork to size.

When hanging your work, never place watercolours in direct sunlight. Watercolour stability has improved, but there is no guarantee that they are completely light fast, and the illustration could fade.

You can scan your illustrations into a computer and print your own greetings cards. This is an excellent way of showing off your new skills.

Societies and exhibitions

Your local area may have art groups that you can join, and where you can take part in exhibitions for minimal cost. It is satisfying to see your work exhibited. If you are asked to price work for sale, think of the hours you have spent working on it, the commission that will be taken by the group, and the cost of framing, and don't underprice your work. If you are especially pleased with an illustration, and not sure that you want to sell it, put a high price on it, so that if it does sell, you will be pleased with the money and yourself.

More formal exhibitions can be very expensive, with galleries taking at least 40 per cent commission. If you sell though organisations like 'art weeks', prices can be kept much lower, and represent an excellent way of buying and selling original work.

The Royal Horticultural Society (www.rhs.org.uk) holds regular exhibitions in London open to well-known artists, as well as newcomers, awarding medals for merit and achievement.

The Society of Botanical Artists (www.soc.botanical-artists.org) holds an annual exhibition in London, which can give you ideas for subject matter and composition. The society runs a distance-learning course in botanical illustration, covering a range of subjects and materials.

You may find other courses run by colleges, adult learning centres, botanical gardens or garden centres. Try to find out what is available in your area.

Botanical illustration goes in and out of fashion regularly. New exhibitions awaken fresh interest. The Royal Botanic Gardens at Kew have a permanent gallery, the Shirley Sherwood Gallery of Botanical Art, which has three or four exhibitions a year.

Further reading

The Art of Botanical Painting by Margaret Stevens and the Society of Botanical Artists, Collins (2004). ISBN 9780007169887.

Botany for the Artist by Sarah Simblet, Dorling Kindersley (2010). ISBN 9781405332279.

The Apple Book by Rosie Sanders, Frances Lincoln Limited (2010). ISBN 9780711231412.

A Passion for Plants: Contemporary Botanical Masterworks by Shirley Sherwood, Cassell & Co (2001). ISBN 9780304361663.

A New Flowering: 1,000 Years of Botanical Art by Shirley Sherwood, Ashmolean Museum, (2005). ISBN 9781854442062.

Treasures of Botanical Art: Icons from the Shirley Sherwood and Kew Collections by Shirley Sherwood, Royal Botanic Gardens (2008). ISBN 9781842462218.

Suppliers

Your local art shop may be your first stop when seeking materials and equipment, as well as advice and support. Do not settle for cheap brands from a stationery shop, but try to get good quality, the best that you can afford. Remember that when things go wrong, poor quality equipment is often to blame.

Online shopping

Jackson's www.jacksonart.co.uk

Ken Bromley www.artsupplies.co.uk

The Society of All Artists (membership only) www.saa.co.uk

ArtiFolk www.artifolk.co.uk

ColnArt www.Colnart.com

London Graphic Centre www.londongraphics.co.uk

Pegasus Art www.Pegasusart.co.uk

Glossary

anther – part of the male reproductive organ that contains the pollen.

botanical plate – a composition planned for a specific space, historically printed from an engraved copper plate.

bract – a modified leaf around the base of a flower.

calyx – a cover enclosing a flower bud.

carpel – the female parts of a flower: ovary, stigma, and style.

corolla – a ring of petals.

Fibonacci sequence – a spiral pattern often seen in nature, e.g. in the seeds of a sunflower, or the scales of a pine cone.

filament – supporting stalk of the anther.

flower – the reproductive part of a plant, consisting of petals, carpel and stamen.

foliage – the leaves of a plant.

form – shape, as shown by light passing over a surface, recorded in illustration by increased colour or tone.

gouache – opaque paint diluted with water.

habit – the way a plant grows.

habitat – the place where a plant grows.

leaf – usually a flat blade growing out from a plant's stem, with a network of veins to feed and sustain the plant.

margin – the outer edge of a leaf.

midrib – the central vein of a leaf.

node – the growing point of a leaf.

ovary – contains the ovules, and swells to become the fruit.

ovules – when fertilised, these become the seeds.

pen and ink – a line drawing showing detail, enlargements and dissections with precision.

pencil – graphite available in a range of softness from 9H to 9B, HB being average.

roots – usually found underground, the parts of a plant that anchor it in the soil, absorbing water and nutrients.

sepal – the outer whorl around a flower.

stamen – the male flower parts: anther and filament.

stem – the structure that supports leaves, flowers and fruit.

stigma – female reproductive organ.

style – stalk linking the stigma to the ovary.

variegation – irregular colouring of a leaf.

veins – a network on and under the surface of a leaf, to supply nutrients to all parts of a plant.

venation – arrangement of veins.

watercolour – translucent paint diluted with water.

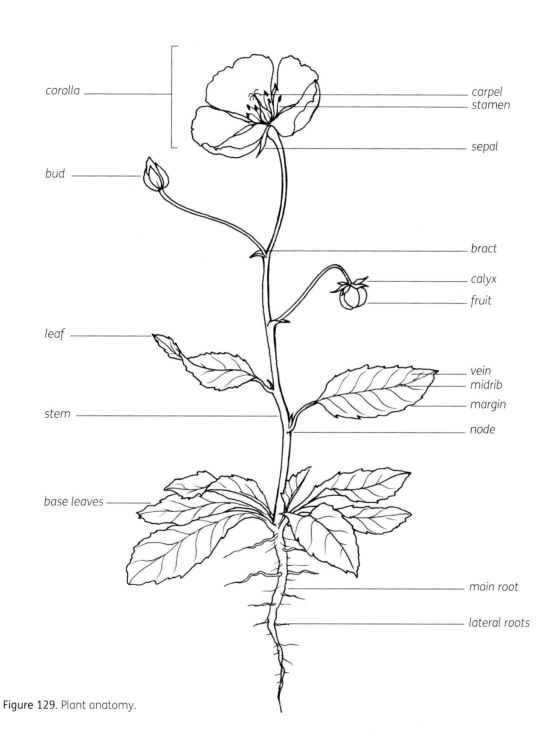

corolla

bud

leaf

stem

base leaves

carpel
stamen

sepal

bract

calyx
fruit

vein
midrib

margin

node

main root

lateral roots

Figure 129. Plant anatomy.

Index